SpringerWienNewYork

Wolfgang Regal
Michael Nanut

VIENNA
A Doctor's Guide

15 walking tours through
Vienna's medical history

Dr. Wolfgang Regal
Vienna, Austria

Dr. Michael Nanut
Vienna, Austria

Translation into English
Roderick O'Donovan

© 2007 Springer-Verlag/Wien • Printed in Austria
SpringerWienNewYork is part of
Springer Science+Business Media
springer.com

Illustration credits:
Bildarchiv des Instituts für Geschichte der Medizin der Medizinischen Universität Wien:
Pages 58, 62, 63, 146, 150, 153, 154, 155; printed with the kind permission of
Doz. Dr. Manfred Skopec.
Doz. Dr. Ernst Zadrobilek: page 83;
All other photographs and illustrations: Dr. Wolfgang Regal

Underground plan and Cityrailway: printed with the kind permission of the Wiener Linien
Plans and maps: Martin Gaal

Graphic Design and Typesetting: Martin Gaal
Printed by: Holzhausen Druck & Medien GmbH. 1140 Vienna
Printed on acid-free and chlorine-free bleached paper

SPIN: 11921080

With numerous illustrations, mostly in colour

ISBN-13 978-3-211-48949-9 Springer-Verlag Wien New York

Preface

Vienna – medically. One can look at Vienna from this perspective, too. There are traces to be found almost everywhere in the city, as not all that long ago Vienna was, from the viewpoint of medical history, regarded as the "Mecca of Medicine".

This book describes a total of 15 walking tours through old medical Vienna. Naturally, these tours are concentrated on the inner city and the ninth district; the former was once the heart of mediaeval Vienna while the Allgemeines Krankenhaus (General Hospital) was established in Alsergrund, as the ninth district is known. However, a number of tours lead visitors outside the city and reveal Vienna from a more hidden perspective, as they lie somewhat outside the beaten tourist path and so have their own special attraction.

 Finding one's way around this book – and hopefully also around Vienna – is easy. Having decided on your tour you can orient yourself according to the respective overview map. But, as man doth not live by medicine alone, there are also a number of notes on art history and a list of good cafés and restaurants. This allows the experiences to be digested in an appropriately Viennese way.

A separate museum tour is devoted to museums without fixed opening hours, which contain special collections that exist only in Vienna.

We wish all of you, both those who are visiting the city for the first time and also those who regard it as "their" city, an enjoyable time exploring this "different" Vienna.

Wolfgang Regal
Michael Nanut
Vienna, spring 2007

Contents

An very brief history of Viennese medicine

Although Celtic and Roman physicians left traces, some of them more than 2000 years old, of their medical activities in Vienna, scientific medicine in Vienna began with the founding of the university in 1365. In the early years of the university the medical faculty played a minor, indeed rather modest, role. This changed, however, when Galeazzo di Santa Sofia was called from Padua to Vienna. He introduced anatomy as a subject and had the first anatomical dissection north of the Alps carried out in 1404. Together with his students he made botanical excursions known as "herbulationen" in the surroundings of Vienna, as he recognised that medicinal plants could be better studied in nature than in books. From the income from anatomical demonstrations Galeazzo had a faculty seal and a sceptre used at graduation ceremonies made. For the cost of the spectacle, the executioner and his trusty aids – the university received only the bodies of persons who had been executed – for instruments, burials, the requiem mass as well as for beer, wine and sweetmeats the students and other spectators had to fork out themselves.

There were no great achievements or innovations in the Viennese medical faculty during this period. The industrious doctor Matthias Cornax should, however, be mentioned. In 1549 he not only considered extracting a dead child from its mother but also carried this out and recorded the operation in words and illustrations. This is the first documented Caesarean section conducted on a living woman. But the Viennese doctor's diploma was, however, not particularly popular among students at the time: it was only when the Dutchman Paul de Sorbait took over the running of the faculty in 1666 that the degree was again regarded as something worth having. He encouraged the study of anatomy and has entered the annals of the faculty as a fearless but ultimately unsuccessful fighter against the plague.

A new era for Viennese medicine began with another Dutchman, Gerard van Swieten, whom Empress Maria Theresia called to Vienna from Leyden in 1745. He reorganised the entire Austrian medical system and reformed the study of medicine in an authoritarian fashion against all kinds of opposition. For Anton de Haën, whom he called to Vienna, he established the first university clinic in the Bürgerspital. De Haën was the first professor of the medical faculty in Vienna who did not instruct from the lectern, as it were, but directly taught students at patients' bedsides. Van Swieten and de Haën are today regarded as the founders of what is called the 1st Viennese School of Medicine. Under van Swieten the faculty acquired its first anatomy theatre and a botanical garden. Around the same time Leopold Auenbrugger developed his brilliant percussion method in Vienna but curiously neither van Swieten nor de Haën recognised its importance.

The successor in office to van Swieten was Anton von Störck who introduced experiments on animals to examine the effects of plant extracts and is regarded as a pioneer in the field of experimental pharmacology. Two theories that developed in Vienna at this time attracted considerable attention throughout Europe: Franz Anton Mesmer's theory of animal magnetism theory and phrenology as described by Franz Joseph Gall. Both of these were as greatly esteemed as they were hotly disputed. Despite all their errors both ideas are today regarded as pioneering concepts.

Viennese medicine achieved world-wide renown with the opening of the Allgemeines Krankenhaus (General Hospital) under Joseph II in 1784. One of the first directors of this hospital, Johann Peter Frank, established the basis for two new sciences: hygiene and forensic medicine. In 1812 Georg Joseph Beer founded the first ophthalmic clinic in the world here. Obstetrics as a separate area of medicine in Austria was established by the precursor of natural birth Johann Lucas Boër. Carl von Rokitansky revolutionised the field of pathological anatomy, Joseph Skoda perfected the methods of physical examination of the sick, making it into a subject that could be taught and learned. Ferdinand Hebra founded scientific dermatology and Ignaz Semmelweis, the "saviour of mothers" made his decisive observations in the old Allgemeines Krankenhaus. In 1874 Billroth carried out here the first successful removal of a larynx and in 1881 the first stomach resection. His predecessor Franz Schuh, surgeon and physician, dared to carry out the first punction of a cardial sac and also carried out the first narcosis by means of ether performed on the European continent. Sigmund Freud worked in a number of departments in this complex and the bloodless surgeon Adolf Lorenz founded modern orthopaedics. Guido Holzknecht established the basis for radiology and radiotherapy under the most primitive of circumstances. Through Tuerck and Czermak the laryngoscope became known worldwide and Friedrich Schaut and Ernst Wertheim developed their pioneering gynaecological operations.

The internists Hermann Nothnagel and Karel Frederik Wenckebach brought internal medicine to new heights. The entire medical world wanted to have the sensational anatomical preparations and textbooks of Josef Hyrtl. Three doctors were awarded the Nobel Prize for research work carried out in the Allgemeines Krankenhaus: the psychiatrist Julius Wagner-Jauregg in 1927 for malaria therapy for progressive paralysis; Karl Landsteiner in 1930 for the discovery of blood groups, and in 1914 Robert Bárány for his work on the vestibular apparatus of the ear.

After the 1st World War Vienna lost its reputation as a world centre of medical research and teaching. However, it proved possible to maintain a high standard of medicine even during the economically period inter-war period. This finally ended on 13 March 1938. After Austria's annexation by Nazi Germany many doctors, researchers and students were driven into exile or died in concentration camps. This represented an enormous loss that from which Austria has not really been able to recover to the present day.

» In my understanding of scientific activity history and research are so inseparably linked that, as I see it, the one is inconceivable without the other. «

Theodor Billroth (1829-1894)
Surgeon

Tour 1

*From the old university
to Stephansplatz*

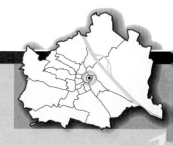

Starting point:
Stubentor Underground station (U3)
1st District, Dr. Karl Lueger Platz
End: Stephansplatz City (Underground station U1/U3)
Duration: about 2 hours (not including visit to the catacombs).

Tuchlauben
Judengasse
Rabensteig
Griecheng.

U Schwedenplatz — Franz-Josefs-Kai

Hoher Markt
Rotgasse
Köllnerhofg.
Fleischmarkt
Lugeck
Sonnenfelsgasse
Bauernmarkt
Kramerg.
Rotenturmstr.
Bäckerstrasse
Old University
Academy of Sciences
Postgasse
Dominikanerbastei
Stubenring

Wollzeile
Dr. Ignaz Seipel-Pl.
Biberstrasse

St. Stephan's Cathedral

U Stephansplatz

Kärtner Strasse
Singerstr.
Blutg.
Grünangergasse
Kumpfg.
Zedlitzgasse
Weiskirchnerstr.

U Stubentor

Weihburggasse
Riemergasse
Jakoberg.
Seilerstätte
Parkring

Let's start our stroll through the old medical Vienna where everything began: in the district around the **Old University**. Here in the university founded in 1365 by Duke Rudolf IV – the oldest university in German-speaking Europe in continuous existence – the foundation stone for the Viennese Medical School that was later to become so famous, was laid. Around the building of the Collegium Ducale – today integrated in the Jesuit College – gradually a "Latin quarter" developed, known as the **Bursenviertel or district**. The Bursen were a kind of student residence where poorer students lived in cramped accommodation. Here they lived, studied, drank and fought – and did not have a particularly good reputation among the population of Vienna – from the Middle Ages to

the opening of the New University on the Ring in 1884.

The centre of this old academic Vienna is today one of the loveliest squares in the city, Universitätsplatz (today known as Dr Ignaz Seipel Platz, 1st District). It can be reached easily from the Underground station at Stubentor: take the exit Dr. Karl Lueger-Platz, walk up Wollzeile a few yards, take a right into Postgasse and then left under the archway of the Jesuit College. The square itself was created through the demolition of the oldest parts of the Viennese library buildings, in which the university hospital was located for a short time. The present, almost theatrical quality of the square dates back to the reconstruction of the university by the Jesuits in 1629,

Academy of Sciences.

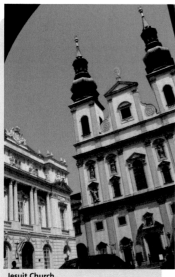

Jesuit Church.

the construction of the Jesuit Church in 1631 and finally to the erection of the Aula building in 1756 – originally an extension to the university, today the seat of the **Academy of Sciences** (Akademie der Wissenschaften).

The aula building – no. 2 Dr. Ignaz Seipel-Platz – erected in the framework of a studies reform programme under **Empress Maria Theresia** was for one hundred years the main building of Vienna university and housed the medical and legal faculties. On the ground floor was the anatomical theatres – the first in Vienna –, the surgery lecture hall, the examinations hall and the chemical laboratory of the medical faculty. A corpse hoist connected the basement and the anatomy theatre. On warm days the smell of the corpses in the building is supposed to have been very unpleasant

according to the law students. Until the 19th century the approach roads to the university district were closed off with chains during lectures to avoid disturbing students. In the year of the 1848 revolutions the military occupied the building, the specimens of the anatomical collection were in great danger. "My supply of preserving went down warlike throats" wrote the famed anatomist **Josef Hyrtl** in looking back at the time. To avoid the spirit preserving the around 2000 specimens also vanishing down the throats of thirsty soldiers, the collection was rapidly moved to the Josephinum on Währinger Strasse. Following rebuilding projects the lecture halls and the corpse hoist are no longer recognisable. The centre of the building is the Ceremonial Hall on the first floor with the ceiling paintings dating from 1755 showing allegories of the four faculties by Italian painter **Gregorio Guglielmi**. **Joseph Haydn** and **Ludwig van Beethoven** once conducted in this splendid hall. The Theology Hall is an insider's tip. It has a magnificent fresco by **F. A. Maulpertsch**, the last great fresco painter of the occident. The busts of deceased presidents of the Academy of Sciences adorn the large aula on the ground floor of the building. Here Austria's most famous doctor **Sigmund Freud** (1856 – 1939) graduated on 31 March 1881

Sonnenfelsgasse

We leave the square going up **Sonnenfelsgasse** and encounter a further trace of the old university: the "domus antiqua" that is connected with the University Church building by an arch. Visitors

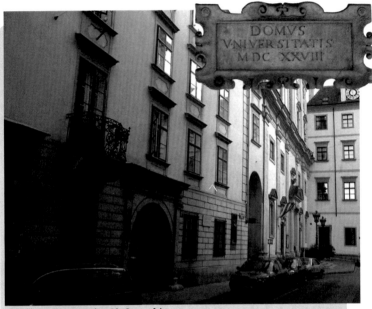

Pedellhaus, "Domus antiqua" in Sonnenfelsgasse.

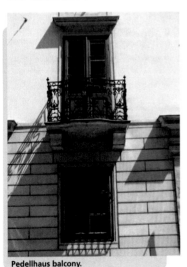

Pedellhaus balcony.

should make sure to see the pretty interior courtyard. From 1627 to 1884 no. 19 Sonnenfelsgasse was the administrative centre of the university. The building with the letters U and V for Universitas Viennensis on the wrought iron work of the balcony recall this fact. The window below the balcony belongs to the room that was once used as the university prison. Until 1783 the university enjoyed the privilege of its own legal administration. People at the university enjoyed a further privilege, if sentenced to death they were not hanged like members of the common public but were executed by the sword.

Sign painted on a building in Bäckerstrasse: "where the cow plays on the board".

Bäckerstrasse, Lugeck

right time. The fly buzzing around unprotected and helpless is supposed to represent spirituality in this game. We turn to the right and at the corner of Bäckerstrasse and **Lugeck** we find the statue of **Johannes Gutenberg**, the inventor of book printing. It is historically documented that there was once a large hole on this square that even had a name on a plan of Vienna dating from 1547: Marcus Curtius Hole. To the present-day we do not know what the function of this hole was. There are many stories about this puzzle. It is also historically proven that one of the most famous doctors in Europe stayed at no. 6 Lugeck in a building known as the Federlhof: the doctor, magician and alchemist **Paracelsus** stayed here during his visit to Vienna.

Through the narrow lane behind the Academy of Sciences we reach **Bäckerstrasse** that runs parallel to Sonnenfelsgasse. No. 12 has a strange house symbol dating from the 17th century, "where the cow plays at the board": a cow wearing spectacles plays with a wolf – although today only the wolf's muzzle has survived – the game Tric Trach, a kind of boardgame that was very popular in mediaeval times and is today known under the name Backgammon. Between the two players stands a man with a fly swat aiming at a fly beside the cow's head. This house sign is interpreted as a sarcastic comment on the disputes between Catholics and Protestants: the cow with spectacles is said to symbolise the Catholics, the wolf the Protestants. The man with the fly swat is meant to symbolise the greedy lawyers who take the winner's side at the

Paracelcus.

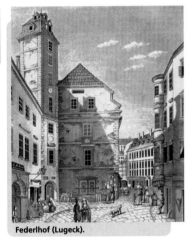

Federlhof (Lugeck).

Rotenturmstrasse, Stephansplatz

With its six-storey tower and observatory the Federlhof was one of Vienna's most splendid buildings. Besides Paracelus the building also housed the military campaigner **Wallenstein**, who had a study of the his stars made here, and the philosopher, mathematician and natural scientist **Gottfried Wilhelm Leibnitz**. At the ice-cream salon on the corner we turn to the left and walk towards St Stephen's Cathedral. Here along **Rotenturmstrasse** the Möringbach flowed from Graben to the Danube, which at the time was roughly where the Danube Canal is today. The Möringbach was no romantic murmering and sparkling stream but a stinking open drain which took the sewage of the city to the river. In 1380 it was made into Vienna's first underground drain.

We soon reach the corner of Rotenturmstrasse and **Stephansplatz**. At the beginning of the 16th century the book-shop and printers of the brothers **Leonhard and Lucas Alantsee** was located here. These brothers ran one of the most famous printing houses of their time in Vienna. Their books, principally scientific and theological works, spread throughout Germany and Italy. Indeed even **Emperor Maximilian I** visited their book shop when he was in Vienna. Lucas Alantsee was clearly an enlightened individual for his time. He was the first Viennese to instruct in his will that his body should be opened after death. **Dr Mathias Cornax**, whom we shall encounter again in tour no. 2 did him this service and reported: "that in the cause of friendship the chest was opened in 1522 and it was found that more than half of the heart was rotten and pus-filled."

Cemetery, Virgil Chapel

We are now at the centre of Vienna, on Stephansplatz. It is hard to imagine that we are here walking across the oldest, formerly most popular and most fashionable cemeteries of Vienna. Most of the graves in this **cemetery** were around the Maria Magdalena Chapel, whose outline is marked in the paving, to the south of the main entrance to the cathedral. The remains of the cemetery chapel that was burnt down in 1781 were found during the excavation work for the Underground station Stephansplatz. During the building work the mysterious **Virgil Chapel** was found under the crypt of this chapel and can be seen from the Underground station. It is strange that in this crypt, which oddly is not mentioned in any chronicles, there is a spring but no nor-

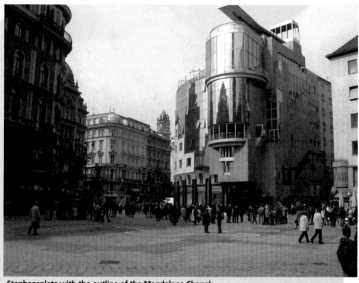

Stephansplatz with the outline of the Magdalena Chapel.

mal means of access such as a door or stairs. Naturally this mystery has given (and continues to give) rise to many wild speculations.

St. Stephen's Cathedral

Before entering **St. Stephen's Cathedral** (Stephansdom) the symbol of Vienna, we stand for a short time in front of the main entrance, the Giant's Gate (Riesentor) in the west front of the cathedral. This entrance could be used only by the aristocracy and higher members of the clergy. The common people had to use the side entrances. On two engaged columns to the left and right of the entrance that are without any structural significance there are (amazingly) depictions in stone of male and female genitals. To the right is the

vulva, possibly a reference to the Singertor, the former men's entrance on the south side of the cathedral, while on

St. Stephen's Cathedral. Symbol of a vulva to the right of the Riesentor.

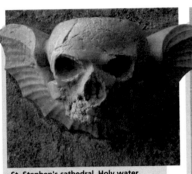

St. Stephen's cathedral. Holy water font at the Crucifix Chapel.

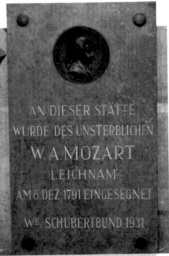

AN DIESER STÄTTE
WURDE DES UNSTERBLICHEN
W. A. MOZART
LEICHNAM
AM 6. DEZ. 1791 EINGESEGNET

Wᴿ SCHUBERTBUND 1931

St. Stephen's cathedral. Plaque in the Crucifix Chapel.

the left is the phallus that could stand for the Bischofstor, the women's entrance. Somewhat above these two columns there are two differently shaped windows in the facade – the only trace of asymmetry in the west facade. There has been much speculation about the deeper meaning of these obvious fertility symbols in a Gothic cathedral. They have been interpreted in different ways, for instance as a reference to a key and a lock that would have been understandable to church visitors, most of whom could not read, or as a reference to a special gnostic belief. The unusual depiction of Christ on the throne with bared knees directly above the Giant's Gate has and continues to provide fuel for speculation.

Catacombs

Since 1529 for reasons of health there had been a ban on burials in the cemetery around St Stephen's. As the corpses were not buried deep enough, and were exhumed again far too soon due to shortage of space, and the semi-decayed corpses were then taken down to the "Cruften" (crypts) beneath the cathedral, the smell of decay, especially in summer, contaminated the air in and around the cathedral. **Emperor Karl VI** finally had the cemetery closed for burials in the ground in 1732. But the expansion of the underworld necropolis, laid out partly in the late Middle Ages, but mostly in the Baroque period did nothing to improve conditions of hygiene that are inconceivable today. In the warm period of the year the smell of decay from the mass graves – between 1735 and 1783 over 10,000 corpses were buried in the **catacombs** – was so bad that on occasions the cathedral could not be used due to the "foul smell" in 1783. **Emperor Joseph II** finally forbade burial in the catacombs, too. Protests made by the church (the parish lost a great deal of money as a consequence), and also

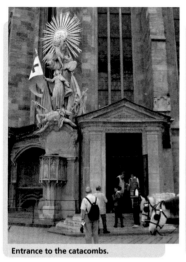

Entrance to the catacombs.

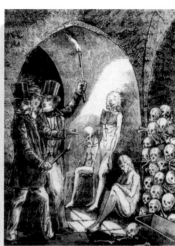

Tour of the catacombs 1872.

a report that said the burials were no source of danger written by **Van Swieten**, the personal physician of Empress Maria Theresia and founder of the first Viennese Medical School were of no avail. The emperor remained unmoved. In the 19th century the crypts under St Stephens were still a kind of cabinet of horrors and tours were organised for tourists thirsting for sensations. There were still mummified corpses in the catacombs with which the tour guides could scare visitors. Through the building of Vienna's spring water supply line in 1873 (which meant that wells in individual buildings were no longer used) the ground water level in Vienna rose gradually. The increasing amount of dampness in the crypts destroyed these mummies entirely. Today, apart from a number of spaces filled with bones, the crypts are empty and offer little that might provoke goosepimples and shudders of horror. But the huge complex is worth seeing for its own sake.

Crucifix Chapel, Christ with a Toothache

After the tour fo the catacombs one can leave the underworld through the **Crucifix Chapel** at the north side of the cathedral. A plaque in the chapel recalls that on 6 December 1791 the remains of Wolfgang Amadeus Mozart were blessed in this chapel – outside the cathedral as this was less expensive. The skull with bat's wings on the outside wall of the chapel was once a holy water font. We now walk around the cathedral in a clockwise direction and at the outside wall of the central choir we come past a niche protected against the pigeons by netting. Here is the statue that is known as the **"Zahnwehherrgott"** (Christ with a Toothache) . Ac-

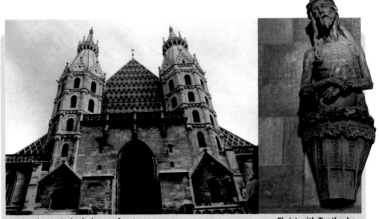

St. Stephen's Cathedral, west front.　　　　　　　　Christ with Toothache.

cording to a legend drunken good-for-nothing young men once mocked this Man of Sorrows for his suffering facial expression and wrapped a cloth around his head, like in treating a headache. On the next day the young men had such terrible toothaches that even Paracelsus could not help them, and they realized that the pains were the punishment for their mockery. Filled with regret they asked for forgiveness on their knees in front of the statue. The pain vanished as quickly as it had started. The statue on the external wall is a copy at which one can still pray for relief from toothache and above all – despite the protective mesh – to make a donation; the original from the former cemetery is now protected from the wind and the weather on the west wall of the north tower hall inside the cathedral..

A few paces further on at the stairs leading up to the south Tower, in the middle of the stony urban desert at a small angle made by the south facade there is a magnificent tree. As is fitting for the proximity of a cathedral this is no normal tree but a so-called Götterbaum (tree of the gods) a Ailanthus glandulosa. The first examples of this tree that is native to China and Korea were brought to

St. Stephen's Cathedral. Tree of the gods.

Europe by Jesuits around the mid-18th century. In Vienna efforts to establish a native silk industry led to the introduction of the ailanthus moth, which was used to produce silk in China, and the ailanthus tree was used to provide food for the silkworms. As they were unsuccessful these attempts were abandoned and the moths released. And so it can sometimes happen that in the densely built-up heart of the city one encounters this moth which, with a wingspan of fifteen centimetres, is the largest and most magnificent moth in Vienna and whose worms live almost entirely on the leaves of ailanthus trees growing wild in Vienna.

St. Stephen's Cathedral, north-west front.

Alte Universität / Old University

Art History

1st District, Dr. Ignaz-Seipel-Platz

The extensive and externally very plain early Baroque complex – the "Jesuitenkolleg" with a library, an observatory and a theatre hall – that is known today as the Alte Universität (Old University), and the Universitätskirche (University Church) or Jesuitenkirche (Jesuit Church) were built around 1630 under the Society of Jesus that had taken over the University of Vienna in 1623.

Jesuitenkirche (Universitätskirche) / Jesuit Church (University Church)

1st District, Dr. Ignaz-Seipel-Platz

The early Baroque building was dedicated to St. Ignatius Loyola and St. Francis Xavier in 1531. It was redesigned by Andrea Pozzo in 1703. The interesting *trompe l'oeil* dome in the nave is an excellent example of illusionistic architecture. Pozzo himself used a light coloured stone slab to mark the ideal position for viewers who wish to experience the full effect of this perspective illusion.

Akademie der Wissenschaften / Academy of Sciences

1st District, Dr. Ignaz-Seipel-Platz 2

The new university building – the "Neue Aula" – was erected under Maria Theresia between 1753 and 1755 to plans by architect Nicolas Jadot. The Ceremonial Hall of this palace-like building has impressive ceiling frescoes showing allegories of the four faculties by Gregorio Guglielmo. The ceiling frescoes in the neighbouring Theological Hall were painted by Franz Anton Maulpertsch.

Stephansdom / St Stephen's Cathedral

Dom- und Metropolitankirche zum hl. Stephan / Cathedral and Metropolitan Church of St Stephen

The symbol and centre of Vienna. The first Romanesque church was dedicated in 1147. Extensive alterations and additions were carried out in the 13th century: Romanesque west façade with the Riesentor (Giant's Door) flanked by the Heidentürme (Heathen Towers). New Gothic triple aisled hall choir erected at the beginning of the 14th century. Gothic extension started in 1359 under Duke Rudolf IV. South tower completed in 1433. The north tower (foundation stone laid in 1450) was never completed. The extensive Baroque interior furnishings from the beginning of the 18th century were almost completely completely destroyed in the final days of the Second World War. Ceremonial reopening on 23 April 1952. The numerous relics in the cathedral include (since 1413) the skulls of the saintly doctors Cosmos and Damian, the patrons of the Viennese Faculty of Medicine. Further skulls of these apparently polycephalous saints, who according to legend even successfully carried out a leg transplantation, are to be found in St. Michael in Munich and in Madrid.

Virgilkapelle / Chapel of St. Virgil

Tel.: +43-1-505 87 4785180 or service@wienmuseum.at
Closed: 1.1., 1.5., 25.12.

This underground crypt from the early 13th century was discovered during the excavation works for Stephansplatz Underground station. It was connected only by a shaft with the Magdalene cemetery chapel whose outlines are today marked in the paving of Stephansplatz. The chapel that lies 12 metres under street level is the largest Gothic interior in Vienna to survive unaltered and can today be seen through a window in Stephansplatz Underground station.

For conservation reasons persons wishing to enter the chapel must make an advance appointment by telephone (c. 20 days before the intended visit).

Restaurants

Cafés

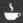 Café Engländer

1010 Vienna, Postgasse 2
Tel.: 966 86 65
Monday to Saturday 8am to 1am,
Sunday and holidays 10am to 1am
Meals served until 11.30pm

Café Prückel

1010 Vienna, Stubenring 24
Tel.: 512 61 15
Daily 8.30am to 10pm
Warm meals available all day

Café Diglas

1010 Vienna, Wollzeile 10
Tel.: 512 57 65
Daily 7am to 12 midnight
Warm meals served until 11.30pm

Café Alt Wien

1010 Vienna, Bäckerstrasse 9
Tel.: 512 52 22
Daily 10am to 2pm
Friday and Saturday to 4am

Note: the addresses of the cafés and restaurants in this list use the Austrian postal code. The code for Vienna is 1XX0, where XX is the district number (if this is a single digit then with a leading "0"), the final (fourth) digit can be used to specify a post office but generally (as here) is left as 0.
Vienna has 23 districts numbered 1 to 23. For example: 1010 is the first district, 1090 the ninth, 1130 is the thirteenth district, 1190 the nineteenth etc.
The number of the individual building is placed after the name of the street. For example in the first entry below:
Café Engländer 1010 Vienna, Postgasse 2, means that this café is in the first district (1010), in the building number 2 Postgasse.

Restaurants

Oswald & Kalb

1010 Vienna, Bäckerstrasse 14
Tel.: 512 13 71
Daily 6pm to 2am
Warm meals served from 6pm to 1am
Good Viennese cuisine

Goldene Zeiten

1010 Vienna, Dr.-Karl-Lueger-Platz 5
Tel.: 513 47 47
Daily 11.30am to 3pm and 5.30pm to 11pm
Excellent Chinese restaurant,
Shanghai and Szechuan cuisine

Figlmüller

1010 Vienna, Bäckerstrasse 6
Tel.: 512 17 60
Daily 12 noon to 12 midnight
Warm meals served from 12 noon to 11pm
Famous for their Wiener Schnitzel

Da Capo

1010 Vienna, Schulerstrasse 18
Tel.: 512 44 91
Daily 11.30am to half-an-hour past midnight
Warm meals served until 11.45pm
Italian specialities!

Gasthaus Pfudl

1010 Vienna, Bäckerstrasse 22
Tel.: 512 67 05
Daily 10am to 12 midnight
Warm meals served from 11.30am to 11pm
Hearty Austrian food

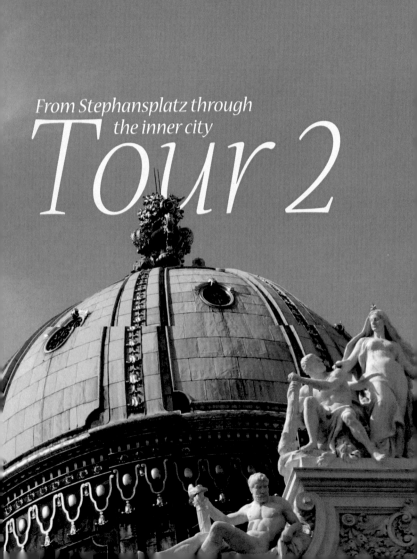

From Stephansplatz through
the inner city
Tour 2

Route

- Stephansplatz
- Kärntnerstrasse
- Weihburggasse
- Franziskanerplatz
- Ballgasse
- Rauhensteingasse
- Himmelpfortgasse
- Neuer Markt
- Albertina

- Josefsplatz
- Michaelerkirche
- Sisi-Museum, Imperial apartments, Silberkammer
- Plague Column on Graben
- Café Korb
- Stephansplatz

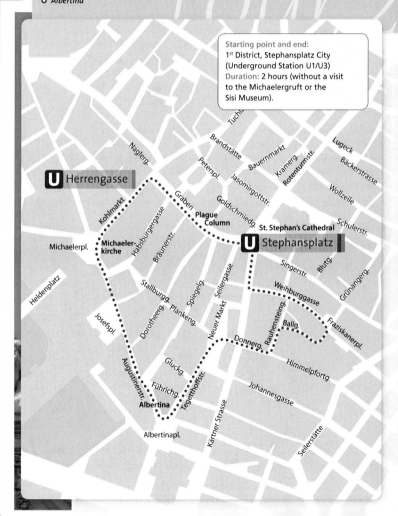

Starting point and end:
1st District, Stephansplatz City
(Underground Station U1/U3)
Duration: 2 hours (without a visit
to the Michaelergruft or the
Sisi Museum).

U Herrengasse

Naglerg.

Tuchl.

Brandstätte

Bauernmarkt

Lugeck

Kohlmarkt

Graben

Peterspl.

Jasomirgottstr.

Kramerg.

Rotenturmstr.

Bäckerstrasse

Wollzeile

Plague Column

Goldschmiedg.

St. Stephan's Cathedral

Michaelerpl.

Michaeler-kirche

Habsburgergasse

Bräunerstr.

U Stephansplatz

Singerstr.

Blutg.

Heldenplatz

Stallburgg.

Spiegelg.

Plankeng.

Seilergasse

Weihburggasse

Rauhensteing.

Grünangerg.

Ball g.

Fraziskanerpl.

Josefspl.

Dorotheerg.

Neuer Markt

Donnerg.

Augustinerstr.

Gluckg.

Himmelpfortg.

Führichg.

Tegetthoffstr.

Johannesgasse

Albertina

Kärntner Strasse

Albertinapl.

Seilerstätte

Stephansplatz, Kärntnerstrasse, Weihburggasse

We leave **Stephansplatz** heading south along one of the most expensive areas in Vienna, **Kärntner Strasse** and after about 200 metres turn left into a narrow street called **Weihburggasse**. Since the start of the 15th century the plot nos. 10-12 Weihburggasse, today occupied by one of the finest Jugendstil buildings in the inner city, has been almost continuously connected with Viennese medicine. After the founding of Vienna University the medical faculty only developed slowly. At that time a university's status was determined by the standard of the theological and arts faculties, at the latter in addition to grammar, rhetoric and dialectics arithmetic, geometry and astronomy were also taught. The medical faculty eventually attracted attention and gained importance through the appointment of **Galeazzo di Santa Sofia** who was called to Vienna from Padua. He introduced the subjects of anatomy and surgery and in 1404 carried out the first dissection of a corpse for instructional purposes north of the Alps. The growing reputation of the medical faculty led to an increase in the number of students and the shortage of space grew more and more pressing. Pleas for additional space went unheard, something that has changed little even today!

The faculty only received its own building in 1419 when the plague carried off Doctor **Nikolaus Hebersdorf**. In his will Hebersdorf, known as Niclas der Bucharzt (literally: Niclas the book doctor) left his house "in the Weihenburg" – today Weihburggasse – and his valuable library to the medical faculty. There is documented proof that a dissection was carried out in the library of this fac-

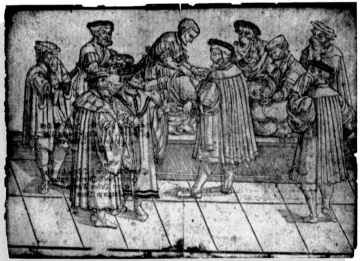

First Caesarean in Vienna on a living patient, 1549.

ulty building in 1452. It is not however clear why the corpse was dissected in the faculty building and not, as was usually the case, in the Heiligengeist Hospital outside the city walls. Perhaps disturbances were feared, as this was the first autopsy on a female corpse in Vienna. The autopsy was conducted on a "female person notorious in the city" who had been drowned in the Danube. Dissections could be carried out only on the bodies of those who had been executed, as they were regarded as little better than carrion.

In the great city fire of 18 July 1525 "the doctors' house was burned and destroyed". The ruins of the building were acquired by the doctor **Johann Enzinger** who after rebuilding it gave it to his daughter as her dowry on the occasion of her marriage the doctor Mathias Cornax. This Dr **Mathias Cornax** has

entered medical history with the first Caesarean section to be documented in writing and illustration carried out on a living woman in the history of medicine. Under Cornax' supervision the city surgeon **Paul Dirlewang** carried out this risky operation on 10 November 1549 and removed a dead child that the patient **Margarete Wolcer** had carried in her womb for four years. Surprisingly, the patient survived this surgery and even became pregnant a second time. This time, too, the birth was accompanied by complications. The doctors could not decide whether to carry out a second Caesarean section and the patient died during the birth. Cornax was an imperial physician and was several times the dean of the medical faculty. His tombstone from St Stephen's Cathedral is today in the Wien Museum

The Jugendstil building erected in 1911 by **Guido Gröger** on this site is today still owned by the doctors of Vienna and houses the headquarters of the Ärztekammer (Chamber of Physicians). A plaque in the entrance hallway tells the building's history.

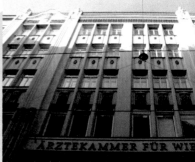

Chamber of Physicians. Memorial plaque in the hall.

Chamber of Physicians.

Franziskanerplatz, Ballgasse

If we now continue along Weihburggasse heading away from Kärntner Strasse we come to one of the most intimate squares in the city: **Franziskanerplatz** (Franciscan Square). This square was created in 1624 through the demolition of a dilapidated building to create a parking area for the coaches of the aristocratic visitors to the Franciscan Church. The building at no. 1 Franziskanerplatz belonged to the imperial "Leib-Medikus" (personal physician) **Paul de Sorbait**. A treatise he wrote warning of the dangers of the plague was not heeded by the government and there was a further catastrophic outbreak in 1679. At the end of this tour we will again encounter traces of Paul de Sorbait. From no. 5 Franziskanerplatz a vaulted passageway leads into narrow,

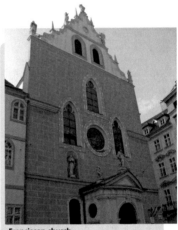

Franciscan church.

winding **Ballgasse** where one immediately feels transported back to the Middle Ages. The Ballspielhaus that once stood at no. 8 was a hospital during the Turkish siege of 1658 where the injured

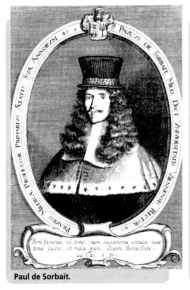

Paul de Sorbait.

Ballgasse.

and sick lying around on the streets were brought – to the "Ball House near the Franciscans". The building became "Der Bürgerliche Tischler Herberg" (The Commoners, Joiner Herberg), as we can read above the doorway, in the first half of the 18th century.

In the second half of the 15th century the house at no. 5 Franziskanerplatz with the archway leading into Ballgasse belonged to Dr. **Johann Tichtl**. After he graduated as a doctor of medicine this once impoverished student from Grein became, in a short period, one of the most sought-after and thus wealthiest doctors in Vienna, who on his house visits was always accompanied by three apothecaries. For a visit he charged one gold gulden for which in Vienna in 1482 you could buy 28 kilos of pork or 850 eggs. As dean of the medical faculty he also promoted many physicians to the title doctor, each promotion bringing him 10 gold gulden. This luminary of Viennese medicine wore a red robe trimmed with pine marten fur (red was then regarded as the height of elegance), which cost about 20 gulden, and he painstakingly documented his takings in his diary. Unfortunately he kept no records of his methods of treatment.

View of the cathedral.

store that now occupies the site, there is a small memorial room with a bust of the gifted composer. The view over the roofs of Vienna alone makes a visit to this exhibition on the seventh floor well worthwhile.

Himmelpfortgasse

Coming from Ballgasse if we take a turn left into Rauhensteingasse we soon reach **Himmelpfortgasse** where we turn right to bring us to Kärntner

Rauhensteingasse

At the end of Ballgasse we find ourselves directly in front of no. 8 **Rauhensteingasse** where Mozart died on 5 December 1791. It was here that he composed his last work, the famous Requiem. That house is no longer standing but in Steffl, the department

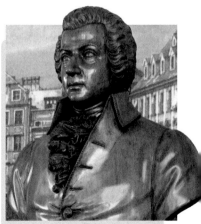

Mozart statue in Steffl department store.

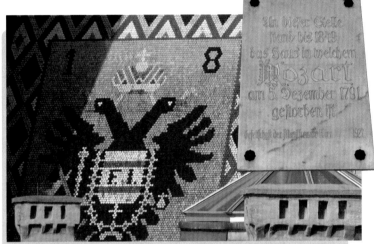

View of the cathedral from the Mozart memorial room.

Mozart memorial plaque on Rauhensteingasse (top right).

Strasse. Crossing Kärtner Strasse a few paces further on we arrive at Neuer Markt, a broad square where in the 15th century tournaments were still held and plays were performed. Later the corn and flour market was located here. In 1770 the naked figures of the famous fountain by Raphael Donner directly in front of us attracted the attention of Maria Theresia's feared "Chastity Commission". To preserve public morals the figures that caused offence vanished for several decades into a depot. Today a copy of the fountain stands on the square; the original is in the Baroque Museum in the Lower Belvedere.

Neuer Markt

No. 9 **Neuer Markt** is also of interest in terms of medical history. A memorial plaque commemorates a doctor who never could or perhaps never wanted

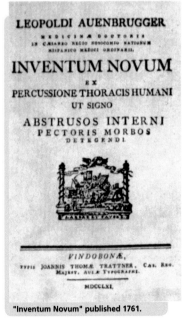

"Inventum Novum" published 1761.

to succeed in presenting himself and his brilliant ideas in the right light, yet he deserves fame for having created the basis for the physical examination of the sick: **Leopold Auenbrugger** (1722 – 1809). In 1761 a slender book appeared in Vienna with the title: "Inventum novum. Neue Erfindung, mittels des Anschlagens an den Brustkorb, als eines Zeichens, verborgene Brustkrankheiten zu entdecken" (New invention. The use of tapping on the chest as a means of discovering hidden chest diseases). Auenbrugger had worked on this book for seven years. The major figures of the Viennese medical world at the time – Gerard van Swieten and Anton de Haen – strangely overlooked their student's revolutionary work. Although Auenbrugger's book was read, medical percussion was eventually forgotten about in Vienna. In France Napoleon's physician, **Jean Nicolas Corvisart** (1755 – 1822), recognised the importance of Auenbrugger's "Inventum novum" for practical medicine. Medical percussion in combination with auscultation, in-

Memorial plaque on the house in which Johann Auenbrugger died.

vented by **Hyacinthe Laenecc** (1781 – 1826). made Paris into a centre for the physical examination of the sick. From now on it was no longer hypotheses and speculation but the five senses that formed the basis for medical diagnosis. Through **Joseph Skoda** (1805 – 1881), who simplified the method and returned it to a strictly physical basis thus enabling it to be taught and learned, medical percussion returned to Vienna. The memorial plaque to the "Founder of Modern Diagnosticism" on Neuer Markt was unveiled by Viennese doctors on the occasion of the 100th anniversary of the death of Leopold Auenbrugger on 18 May 1909.

The best-known building on Neuer Markt is, however, without any doubt the Kapuzinergruft (Capuchin Crypt) that directly adjoins the Auenbruggerhaus. Almost all the Habsburgs who died since 1663 are buried in this crypt – a total of 146 bodies in sarcophagi decorated with greater or lesser degrees

Leopold Auenbrugger.

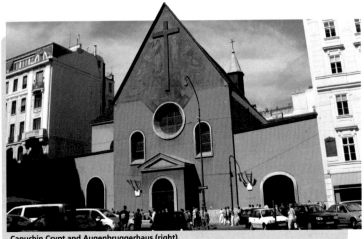

Capuchin Crypt and Augenbruggerhaus (right).

of lavishness. The only non-Habsburg is the Maria Theresia's governess, Countess Fuchs, whose body, by order of the empress (and despite the serious misgivings of her advisors) was laid to rest in the Kapuzinergruft. The modest sarcophagus of Princess **Elisabeth of Würthemberg**, the first wife of Emperor Franz II, in the Kapuzinergruft recalls the obstetrician **Johann Lukas Boër** (1751 – 1835), who established obstetrics in Austria as a separate subject. Personally appointed by Emperor Joseph II, from 1789 he directed the department for poor women in childbed in the Allgemeines Krankenhaus (General Hospital). The emperor also appointed him personally to assist the princess at her first birth. Boër, a gifted obstetrician and a believer in natural birth – only 0.4 per cent of his deliveries were made by forceps whereas the figure for prominent obstetricians in Germany was up to 40 per cent – in this case unfortunately had to carry out a forceps delivery. After

the normal delivery complications arose. Boër, although he spent the night after the delivery in the Hofburg, could initially not be found in the vast complex. When he was eventually discovered it was too late, the princess had bled to death. And although the Emperor told him personally and also stated publicly that Boër was not to blame, his reputation as an obstetrician was ruined. The flow of patients to his practice dried up. The only option left to him was to devote himself to his department in the Allgemeines Krankenhaus and to teaching. And this is what he did. Through Boër the Viennese school of obstetrics achieved world renown.

Albertina

If we proceed from Neuer Markt in the direction of **Albertina Platz**, we move through the site of what was once the huge (even in contemporary terms) complex of the Bürgerspital that once

extended from Kärntner Strasse to Augustinerstrasse. Today not a single trace of this hospital is left. Until the opening of the Allgemeines Krankenhaus in 1784 the Bürgerspital was the largest welfare institution in the city. In 1753 the hospital received an order from the highest authority to make rooms available for foreign "Medicos and Chyrurgos" (physicians and surgeons). This was to allow the establishment of a practical teaching academy for **Anton de Haen** (1706 – 1776) whom **Van Swieten** had brought to Vienna from Holland. In 1754 van Haen began here with the system of teaching at the sickbed, which was entirely new for Vienna. For centuries medicine had been taught, from the lectern – far removed from the truly sick. The medical university clinic was located in the Bürgerspital from 1754 to 1776. Instruction at the sickbed and de Haen's personal charisma attracted many students to Vienna. De Haen introduced the taking of the body temperature in his clinic and proved that the feeling of coldness during shivering fits is actually

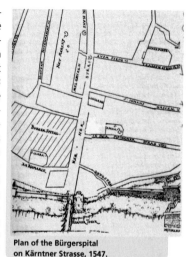

Plan of the Bürgerspital on Kärntner Strasse, 1547.

due to a rise in temperature. At the time this was regarded as a sensational discovery. Alongside van Swieten de Haen is certainly one of the main figures responsible for the rise to fame of Viennese medicine that was later to achieve world renown. The opening of

Albertina.

Bürgerspital, Anton de Haen (top right).

the Allgemeines Krankenhaus on 16 August 1784 signalled the end of the Bürgerspital.

Josefsplatz, Michaelerkirche

Our route leads us from Albertinaplatz, with its impressive monument against war and fascism, across Augustinerstrasse, past **Josefsplatz** with the National Library and down Reitschulgasse – where the Lippizaner Museum is now housed in the former Court Apothe-

The old Court Apothecary, now the Lipizzaner Museum

cary – to Michaelerplatz where Vienna's finest crypt is located under the **Michaelerkirche**. Between 1631 and 1784 around 4000 bodies were buried here. Around 250 coffins are arranged in long rows, some of them painted like peasant furniture. A number of wonderful mummified corpses lie in open coffins. Constant temperature and a slight draught have preserved the

Equestrian monument to Joseph II.

Sculptures on the roof parapet of the National Library.

View of the Michaelerkirche from the Michaelkuppel.

corpses and even their elegant sumptuous clothing, in excellent condition. The most famous corpse in this crypt is that of Maria Theresia's court poet, **Pietro Metastasio**, who wrote the libretti for a number of Mozart's operas .The most touching mummified corpse is that of a young woman who died during pregnancy. The outline of her unborn child can still be seen beneath her abdominal wall.

Sisi Museum, Imperial Apartments,
Imperial Silver Collection

If you have no particular interest in seeing mummies and catacombs, from Michaelerplatz you have an opportunity to visit the **Imperial Apartments**, the **Sisi Museum** and the **Imperial Silver Collection**. The entrance to these museums is in the Michaelerkuppel, past the mighty wrought iron entrance gates to the Hofburg and on the right in the large domed space. Here, in addition to the offices and domestic rooms of Emperor Franz Joseph I and Empress Elisabeth (better known as Sisi), visitors can see numerous objects from the private life of the celebrated but ultimately unhappy empress. The objects exhibited range form highly personal pieces such as toilette articles and dental hygiene equipment to letters and photograph albums or the official autopsy report written in French. The sharpened triangular file with which the anarchist **Luigi Lucheni** stabbed the empress to death on 10 September 1898 in Geneva is also shown here.

After the attack the empress succeeded in dragging herself on board a nearby steamship from where she was carried

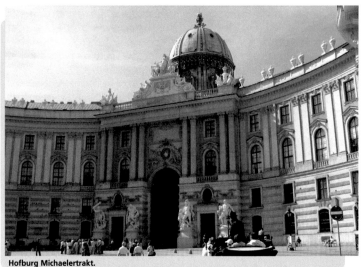

Hofburg Michaelertrakt.

on an improvised stretcher made of sail linen and oars to the Hotel "Beau-Rivage". Here, despite immediate medical attention, the empress died. The file used by the assassin had entered her left heart chamber through the lung. The Viennese Forensic Medicine Institute was presented with the murder weapon by the Swiss Forensic Medicine Institute on the occasion of the 600th anniversary of the Vienna University. The head of murderer (he hanged himself in his cell twelve years after the deed and, as was the case with all spectacular criminals, his brain was then examined in a post-mortem) was also on permanent loan to Vienna. From 1985 to 2000 it was kept in the Pathological-Anatomical Federal Museum in the Narrenturm. In February 2000 it was buried quietly in one of the "anatomy graves" in the Central Cemetery in Vienna, where the corpses from the Anatomical Institute are also interred.

The empress's 63-piece travelling medical kit is also of medical historical interest. Believing that the empress had suffered a circulatory collapse she was given "a piece of sugar dipped in ether" immediately after the assassination attempt. Up to recently it was completely unclear how ether had been found so quickly in the hotel. When the travelling first-aid kit was found and the contents identified this puzzle could be solved. This "portable pharmacy" also contained bandages, disinfectant soap, quinine pills to lower fever, cube sugar, the famed Hofmann' sche drops, ether that curiously was used to treat fainting attacks, Goulard's extract (vinegar of lead) for cold compresses, opium for diarrhoea and stomach cramps but also used to treat coughs, and a cocaine syringe. Cocaine was regarded as a harmless tonic, and Sigmund Freud also recommended it. We do not know how often it was given to Empress Elisabeth. The Museum attempts to make an authentic examination of the life of this tragic empress and to communicate to visitors the myth and the reality behind the familiar Sisi clichés formed mostly by the Sisi films starring **Romy Schneider**.

Plague Column on Graben

We proceed up Kohlmarkt past the world-famous "K. und K. Hofzuckerbäcker" Demel, and at the end of the street turn right into Graben. In this broad and extremely elegant street with its exclusive shops there is nothing left to remind us of the Stadtgraben (city ditch) that gave the street its name. Part of the ransom paid by the English for the release of Richard Lionheart was supposedly used to fill in this ditch. At the centre of Graben is an impressive Baroque monument: the **Pestsäule** or Plague Column. It not only commemorates the devastating plague epidemics that regularly occurred in Vienna but also a fearless but ultimately unsuccessful battler against the plague: Vienna's first "city doctor" **Paul de Sorbait** (1624 - 1691). In the second half of the 17th century de Sorbait was Vienna's most famous doctor. As dean of the faculty he battled against superstition, sorcery, quacks, apothecaries, the "blindness of the authorities" and doctors who infringed the regulations

Sorbait's epitaph in St. Stephen's.

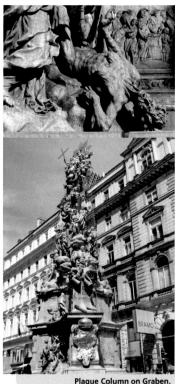

Plague Column on Graben.

governing their profession. He fought with some success against these opponents but he was powerless against the plague. Sorbait came to Vienna in 1652 and began his career in the Bürgerspital. In 1666 he took over the chair of practical medicine at the University of Vienna. When the plague raged in Vienna even the best doctors could do hardly anything for their patients. It was not known how the infection was spread and as a therapy the doctors often recommended regular ringing of the bells both for spiritual reasons as well as because "still air like still water grows stagnant, therefore when there is no breeze it is recommended that artificial movement of the air be created by ringing bells." Sorbait and twenty other plague doctors bravely treated the populace. Wearing curious kinds of masks they sought to protect themselves against the "sticky sparks of plague". Their therapies – cupping, bloodletting and enemas – were scarcely more ef-

fective than prayers and the Holy Trinity columns. The great plague epidemic of 1679 in Vienna claimed between twelve and fifteen thousand victims, which, given a population of 80,000, was a huge number. At that time a wooden column stood on Graben, which **Leopold I** had replaced in 1693 by the magnificent marble Baroque monument that we see today. Supplicatory processions to this column at the start of the cold season of the year actually did help physically against the plague. But it was

not Heaven that took pity and withheld divine retribution for the debauched life in the sinful city but the biology of the rat flea that took effect. At temperatures below 10 degrees Celsius the flea freezes and, as the plague cannot then be spread, it gradually dies out.

Paul de Sorbait died of a stroke in 1691. An epitaph with an inscription he wrote himself – "I was a musician, orator, philosopher, soldier, doctor, professor, courtier, rector magnificus; now I am a shadow, nothing" – in the Apostelchor of St. Stephen's cathedral commemorates this fearless fighter against the plague and other adversities.

Café Korb, Stephansplatz

Although it is only a few paces from here back to Stephansplatz, due to the many enticing "Schanigärten" (the Viennese term for the outdoor street cafés), if the weather is good it can take some time to traverse this short distance. On Graben the perfectly restored elegant underground public lavatories in the finest Jugendstil (Art Nouveau) offer a sight that should not be missed. And, if you have some time to spare, then take a look inside **Café Korb**. This cult café house with a glorious past and present is not far away – from Graben along Jungferngasse, to the left around the Peterskirche and through Kühfussgasse to the corner of Brandstätte and Tuchlauben. In 1908 this was the regular meeting place of Sigmund Freud's Wiener Psychoanalytische Vereinigung (Viennese Psychoanalytical Association), as the famous Wednesday society called itself after it was re-established. Having sufficiently enjoyed the "culture of the soul and the palate" one can then stroll at a leisurely pace along Brandstätte back to **Stephansplatz**.

Peterskirche.

Art History

Donner Fountain

actual name Providentia Fountain
1st District, Neuer Markt

Raphael Donner created this fountain, perhaps the loveliest in Vienna, in the years 1737–39 as a commission from the Vienna City Council. It was the citizens of Vienna who financed this monument and there is not a single imperial or ecclesiastical symbol on the fountain. The figure of Providentia at the centre is surrounded by personifications of four rivers: the Enns – a bearded ferryman, the March – a river goddess with a shell, the Traun – a young man with a trident, and the Ybbs – a nymph with a vase. In 1773 these figures perched on the edge of the basin were removed on account of their shameless nakedness but they were put back in place in 1801. The original figures, which are made of lead, have been kept in the Austrian Baroque Museum in the Lower Belvedere since 1921. The figures that now decorate the fountain on Neuer Markt date from 1873.

Capuchin Crypt and Capuchin Church

1st District, Neuer Markt, Tegethoffstrasse 2
Opening hours: daily from 10am to 6pm
Closed on 1 and 2 November
Telephone 512 68 53 / 16 Fax: 512 68 53 / 19

The Imperial Crypt – Capuchin Crypt – has been the burial place of the Habsburgs in Vienna since 1633. 12 emperors, 19 empresses and many other members of the Habsburg have found their last resting place here. The crypt contains a number of artistically interesting and eerily beautiful sarcophagi. Coffins from a period of three hundred years offer an impressive art historical monument to the Habsburg burial cult.

Albertina

1st District, Augustinerstrasse 1
Opening hours of the Albertina Museum
Monday: 10am – 6pm
Tuesday: 10am – 6pm
Wednesday: 10am – 9pm
Thursday: 10am – 6pm
Friday: 10am – 6pm
Saturday: 10am – 6pm
Sunday: 10am – 6pm
Opening hours of the restaurant DO & CO in the Albertina
Monday to Sunday: 9am – 12 midnight

In 1795 Emperor Franz I gave Maria Theresia's guest-house to Duke Albert von Sachsen-Teschen as his Viennese residence. Duke Albert had the building extended and altered by Louis von Montoyer from 1801 to 1804. After heavy damage in the Second World War parts of the building were radically altered and rebuilt. The Albertina developed out of the collection put together by Duke Albert that was combined in 1920 with the Kupferstichkabinett (cabinet of copperplate engravings) of the Imperial Court Library. With around 65,000 drawings and 1 million sheets of graphic works this is possibly the largest collection of graphic art in the world.

Albertina

Michaelerkirche

1st District, Michaelerplatz

The "k.k. Hof-Stadt-Pfarr- und Collegium-skirche St. Michael" (Imperial and Royal Court Parish and Collegiate Church of St. Michael) is one of Vienna's oldest churches (construction started around 1220) and, thanks to the diversity of architectural styles, the many monuments and art works from Roman-esque to contemporary, it is also one of the most interesting.

The church is open from 7am to 10pm

Tours of the crypt:
Monday to Friday: 11am, 2pm, 3pm, 4pm
Saturday: 3pm, 4pm.
Duration: 30 minutes

Special tours:
Every first Monday in the month at 6:30pm
Duration: 1 hour
Cost: donation from 9 euro
Meeting point in the church on the right at the back

Tel.: 01 533 8000; Fax: 01 533 8000/31
pfarre@michaelerkirche.at

Hofburg

1st District, entrance on Michaelerplatz

Even a very superficial description of the 600-year building history of the mighty complex that makes up the Hofburg with its many wings, courtyards and collections would fill a sizable book. We must there-fore confine ourselves to a few remarks. The building was started by King Ottokar in 1275. The original castle complex, erected around what was later to be called the Schweizerhof (Swiss Yard), had a tower at each of its four corners and was – as can still be clearly seen today – surrounded by a moat, the draw-bridge was at the Schweizertor (Swiss Gate). The various phases in the development of this palace up to 1913 can be clearly recog-nised at three places within the complex: the Gothic phase around Schweizerhof, the Baroque phase around the square known as "In der Burg", while Heldenplatz (Heroes Square), bordered in the south-east by the mighty range of the "Neue Hofburg", reflects the era of Emperor Franz Joseph I. The devel-opment and redesign of the parts of the Hof-burg facing onto Michaelerplatz was carried out from 1889 to 1893, also during the reign of Franz Joseph.

Collections in the Hofburg:

Schatzkammer
Treasury

Entrance: Schweizerhof, Säulenstiege
Tel.: (+43 1) 52 52 40
e-mail: info.kk@khm.at
www.khm.at
Wednesday to Monday: 10am – 6pm

Silberkammer, Sisi-Museum and Kaiserappartements
Silver Collection, Sisi Museum and Imperial Apartments

Entrance Michaelerkuppel
Tel.: (+43 1) 533 75 70
www.hofburg-wien.at
Daily: 9am – 5pm
July and August daily: 9am – 5:30pm

Hofjagd- und Rüstkammer
Collection of Arms and Armour

Neue Hofburg, 1st District, Heldenplatz
Tel.: (+43 1) 52 52 44 60
www.khm.at
Wednesday to Monday: 10am – 6pm

Sammlung alter Musik-instrumente
Collection of Ancient Music Instruments

Neue Hofburg, 1st District, Heldenplatz
Tel.: (+43 1) 52 52 44 71
www.khm.at
Wednesday to Monday: 10am – 6pm

Ephesos Museum

Neue Hofburg, Mittelportal
Tel.: (+43 1) 52 52 44 76
www.khm.at
Wednesday to Monday: 10am – 6pm

Museum für Völkerkunde
Museum of Ethnology

Neue Hofburg, right-hand side wing
Tel.: (+43 1) 53 43 00
www.ethno-museum.ac.at

Österreichische National-bibliothek
Austrian National Library

1st District, Josefsplatz
Tel.: (+43 1) 53 41 04 64
www.onb.ac.at
Tuesday to Sunday: 10am – 6pm
Thursday: 10am – 9pm
Tours Thursdays, 6pm and by appointment

Spanische Hofreitschule
Spanish Riding School

1st District, Josefsplatz 1, Gate 3
Tel.: (+43 1) 533 90 31 13
www.spanische-reitschule.com
For times of performances and tickets
consult the homepage

Lippizaner Museum

1st District, Reitschulgasse 2
Tel.: (+43 1) 52 52 45 83
www.lipizzaner.at
Daily: 9am – 6pm
Special tours on request
Tel.: (+43 1) 52 52 44 16 (Dept. "Museum und Publikum", Ms. Hochleitner)
Email: lipizzaner@khm.at

Peterskirche / Church of St. Peter

1st District, Petersplatz

That this church was founded around 800 by Emperor Charlemagne is most probably only a legend. It is first mentioned in documents in 1137 and could, accordingly, be the oldest church in Vienna, but today there is nothing to be seen of the original church. The present-day Peterskirche, built in 1733 to plans by Lucas von Hildebrandt, is a Baroque *gesamtkunstwerk*, which, however, almost conceals itself between the tall buildings of Petersplatz. It reveals its full Baroque magnificence only when you are standing directly in front of it.

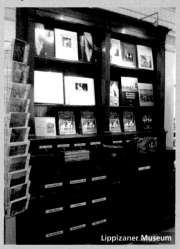

Lippizaner **Museum**

Restaurants

Cafés

 ### Aida

1010 Vienna, Stock-im-Eisen-Platz 2
Tel.: 512 29 77
Monday to Saturday 7am to 9pm
Sunday and holidays 9am to 9pm

Cafe Europa

1010 Vienna, Kärntner Strasse 18
Tel: 515 94-0
Daily 7am to 11pm

Café Demel

1010 Vienna, Kohlmarkt 14
Tel.: 535 17 17
Daily 10am to 7pm

Café Tirolerhof

1010 Vienna, Führichgasse 8
Tel: 512 78 33
Monday to Saturday 7am to 10pm
Sunday and holidays 9.30am to 8pm

Gerstner Café Konditorei

1010 Vienna, Kärntner Strasse 13-15
Tel.: 512 49 63-77
Monday to Saturday 8.30am to 8pm
Sunday and holidays 10am 6pm

 ### Café Bräunerhof

1010 Vienna, Stallburggasse 2
Tel.: 512 38 93
Monday to Friday 8am to 9pm, Saturday 8am to 7pm, Sunday and holidays 10am to 7pm

Kleines Café

1010 Vienna, Franziskanerplatz 3
Daily 10am to 2am

 ### Café Griensteidl

1010 Vienna, Michaelerplatz 2
Tel.: 535 26 92
Daily 8am to 11.30pm

Inns and restaurants

Do & Co Albertina

1010 Vienna, Albertinaplatz 1 (on the rampart)
Tel.: 532 96 69
Daily 10am to 7pm
Daily 9am to 12 mifnight
Warm meals served all day

 ### Yohm

Asia Restaurant
1010 Vienna, Petersplatz 3
Tel.: 533 29 00
Daily 12 noon to 3pm and 6pm to 12 midnight

Restaurants

Zum Weissen Rauchfangkehrer

1010 Vienna, Weihburggasse 4
Tel.: 512 34 71
Viennese cuisine, somewhat more expensive
Tuesday to Saturday 6pm to 12 midnight

Novelli bacaro con cucina

1010 Vienna, Bräunerstrasse 11
Tel.: 513 42 00-0
Monday to Saturday 11am to 1am
Meals serverd from 12 noon to 2pm
and 6pm to 11pm

Palmenhaus im Burggarten

1010 Vienna, Burggarten
(entrance near the Albertina)
Tel.: 533 10 33
Daily 10am to 2pm

Restaurant Meinl am Graben

1010 Vienna, Graben 19
Tel.: 532 33 34-6000
Monday to Wednesday 8.30am to
12 midnight, Thursday, Friday 8am to 12 mid-
night, Saturday 9am to 12 midnight

Zum schwarzen Kameel

1010 Vienna, Bognergasse 5
Tel.: 533 81 25
Monday to Saturday 8.30am to 12 midnight
Warm meals served from 12 noon to 2.30pm
and from 6pm to 10.30pm

Führich

1010 Vienna, Führichgasse 6
Tel.: 513 08 80
Daily 10am to 12 midnight

Immervoll

1010 Vienna, Weihburggasse 17
Tel.: 513 52 88
Daily 12 noon to 12 midnight

Zu den 3 Hacken

1010 Vienna, Singerstrasse 28
Tel.: 512 58 95
Monday to Saturday 11am to 11pm
Local Austrian food

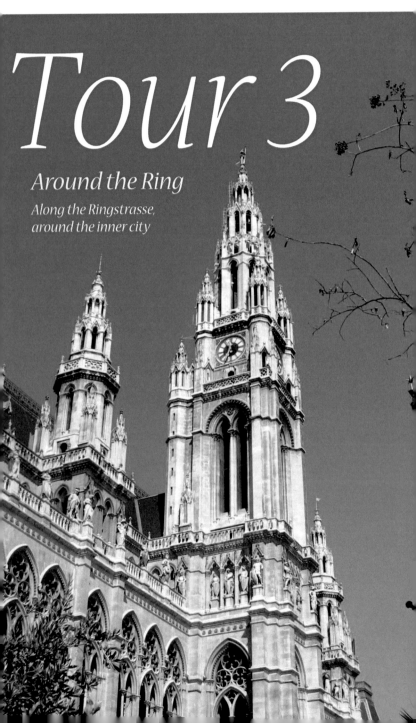

Tour 3

Around the Ring

Along the Ringstrasse,
around the inner city

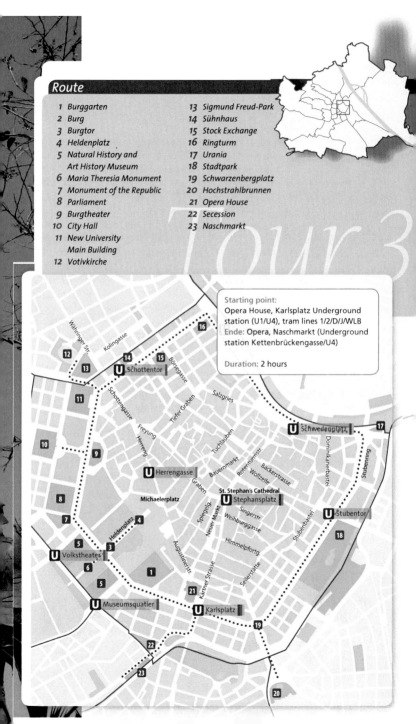

Tour 3

Starting point:
Opera House, Karlsplatz Underground
station (U1/U4), tram lines 1/2/D/J/WLB
Ende: Opera, Naschmarkt (Underground
station Kettenbrückengasse/U4)

Duration: 2 hours

For a leisurely stroll the tour around the inner city of Vienna is somewhat too strenuous. The unique monumental Ringstrasse, which is six and a half kilometres long, encloses the inner city in a horseshoe-like shape and at the northeast it is completed by the quay along the Danube Canal to form a ring. The "Ring" as it is usually known in Vienna is 57 metres wide, has avenues of trees and a bicycle path that was originally intended for horse riders. The Ringstrasse, which – following the demolition of the old fortified walls – was created by a decree of Emperor Franz Joseph as part of an urban expansion plan was opened on 1 May 1865 and gradually developed into Vienna's most splendid street as monumental buildings in the various historicist styles fashionable at the time were erected one after the other and airy parks laid out between them.

Burggarten, Burgtor, Heldenplatz, National History and Art History Museum, Maria Theresia Monument

The more sporty visitor might like to use a bicycle for this tour – bikes can be conveniently rented at several points along the way – others can take the tram. Seated in the no. 1 tram one can tour the Ringstrasse in comfort, looking left and right at the magnificent buildings. If you decide on the tram the best point to start this tour is the stop of the no.1 line at the Vienna Opera House on the stretch of the Ringstrasse known as Kärntner Ring. The line 1 circles the inner city in a clockwise direction, just like the motorised traffic. On this tour you can gain a first impression that you can later deepen and expand as you wish. The tram has barely left the stop where you got on when you see on the right the **Burggarten** followed by the **Burgtor**, **Heldenplatz** and the Hofburg, on

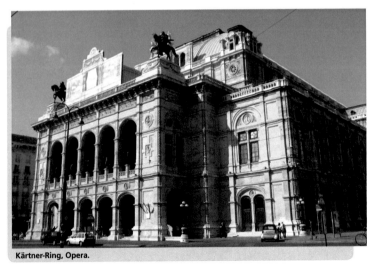

Kärtner-Ring, Opera.

Gerard van Swieten on the Maria Theresia monument.

the left are the equally palatial buildings of the **Art History and Natural History Museums**. Between them is Vienna's largest and most expensive monument: the gigantic **monument to Empress Maria Theresia** – unveiled on 13 May 1888 – on which the sculptor **Kaspar von Zumbusch** worked for 13 years. On the lower part of the monument the Empress is surrounded by her closest advisors, statesmen, commanders and artists – including **Gluck, Haydn** and **Mozart** – and scientists, as the supports for her throne, so to speak, or the columns that carried her reign. To the left, directly beside the Empress because "of all her advisors he was the closest to her", is the Dutchman **Gerard van Swieten** (1700 – 1772), the empress's personal physician and founder of the 1st Viennese School of Medicine. It was he who 250 years ago made Vienna into one

of Europe's leading medical centres. He was just as absolutist and authoritarian as the empress and reorganised health care in Austria as well as the study of medicine at Vienna University. He introduced teaching at the patients' bedside, encouraged the subject of pathological anatomy, set up a chemical laboratory to examine the plants raised in the bo-

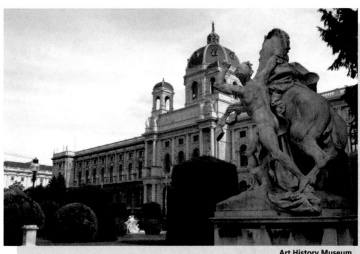

Art History Museum.

tanical gardens and demanded that students pass a rigorous exam at the end of their studies, replacing a system by which they had graduated (on paying considerable sums of money) after six years of studies. The building containing the "aula" of the old university on Dr Ignaz Seipel-Platz in the first district, which we encountered at the start of our first tour, is the monument to his university reform work. Austrian doctors have also given him a monument: the general society of Austrian physicians today bears the name "Van Swieten Gesellschaft".

Monument of the Republic, Viktor Adler.

Monument of the Republic

Where "Burgring" turns to the right leading into "Dr Karl Lueger Ring" there is a **monument to the Republic** on the left-hand side. At the centre of this monument is the bust of the doctor and politician **Victor Adler** (1852 – 1918). A sentence by the famous German pathologist **Rudolf Virchow** best describes the life of this social reformer: "Medicine is a social science and politics is nothing other than medicine at a large scale" Adler worked as a doctor for the poor at a now famous address, no. 19 Berggasse. Adler inherited this building from his father, but it is not due to him that the address is so famous today. **Sigmund Freud** took over the practice in 1892 and lived and worked here until he fled to London. Throughout his life Victor Adler, who was social democrat politician, fought for social and democratic progress. But he did not live to experience the founding of the Republic of Austria as he died two days beforehand. This monument was erected in 1928 on the tenth anniversary of the founding of the Republic.

Parliament, Burgtheater, City Hall, New University Main Building

After the **Parliament** building on the left the tram stops directly in front of the **Burgtheater** on the right-hand side of the Ring. Directly opposite the theatre building the monumental **City**

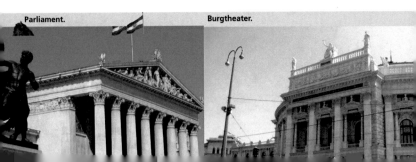

Parliament.

Burgtheater.

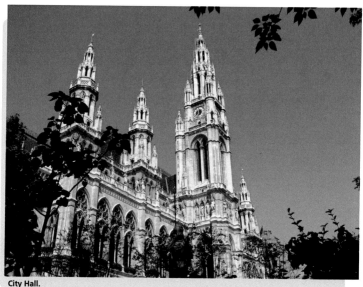

City Hall.

Hall (Rathaus) dominates the broad expanse of Rathausplatz. Shortly after the Burgtheater stop the tram travels past the famous Café Landmann, which Sigmund Freud, like many other well-known figures from the world of art and politics, liked to frequent. Just past the park on the left is the **main build-ing of the New University** that was opened in 1884. The so-called faculty pictures by **Gustav Klimt** that were intended for the Festsaal (ceremonial hall) provoked such a heated response – the painting "Medicine", which today exists only as a copy in the Leopoldmuseum in the Museumsquartier (the original was

Main building of the New University, Hall of Fame.

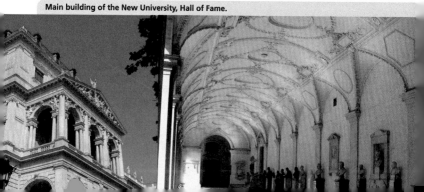

burnt at the end of the Second World War) was even denounced as pornographic – that Klimt lost his nerve, threw in the towel, withdrew his paintings and never again accepted a state commission. The architectural and spatial centre of this building is the Arkadenhof (arcaded courtyard) that was planned from the very start as the university's hall of fame. In what is called the "Medizinergang" (doctors' corridor), which, looking from the main entrance, is on the right-hand side of the courtyard, there are busts of almost all the major famous doctors of Vienna. This is a unique ensemble of artistically valuable works by important sculptors. It is striking that there is not a single woman among all the statues in the arcade, even though a number of famous female scientists have researched and taught at the University of Vienna. The only objects in Vienna University's hall of fame that refer to women are a memorial tablet to the

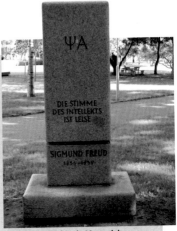

Sigmund-Freud-Park. Memorial.

poet and honorary doctor of the university, **Marie von Ebner-Eschenbach**, and the statue of the nymph Kastalia at the fountain in the centre of the courtyard. All the same, a visit to the Arkadenhof is highly recommended. Visitors should also not miss taking a look into the magnificent main reading room of the university library that one reaches from a staircase on the right, at the end of the "Medizinergang".

Votivkirche, Sigmund-Freud-Park

After the university the tram travels past to a wide, open space on the left, with the **Votivkirche** in the background, the Votivpark around the church and the **Sigmund Freud-Park** with a memorial erected in 1985. At the unveiling there was an inscription below the letters Psi and Alpha that Freud used as an abbreviation for psychoanalysis, which read: "die Stimme der Vernunft ist leise" ("the voice of the intellect is a soft one"). But Freud in fact wrote: "Die Stimme des

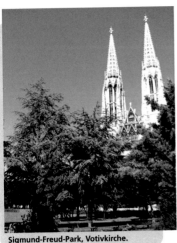

Sigmund-Freud-Park, Votivkirche.

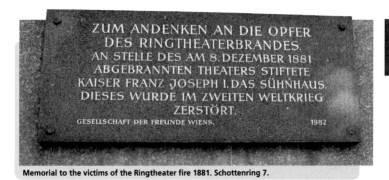

ZUM ANDENKEN AN DIE OPFER
DES RINGTHEATERBRANDES.
AN STELLE DES AM 8. DEZEMBER 1881
ABGEBRANNTEN THEATERS STIFTETE
KAISER FRANZ JOSEPH I. DAS SÜHNHAUS.
DIESES WURDE IM ZWEITEN WELTKRIEG
ZERSTÖRT.
GESELLSCHAFT DER FREUNDE WIENS. 1982

Memorial to the victims of the Ringtheater fire 1881. Schottenring 7.

Intellekts ist leise, aber sie ruht nicht, ehe sie sich Gehör verschafft hat" ("the voice of the intellect is a soft one but it does not rest until it has gained a hearing"). It is impossible to clarify today why this quotation was alterered, but in the 1990s the word "Vernunft" (reason) was corrected to read "Intellekt" (intellect) – as can still be seen today.

Sühnhaus

A short distance past the station Schottentor a memorial plaque on no. 7 Schottenring, on the left-hand side of the Ring, commemorates one of the great fire catastrophes of the 19th century. In the Ringtheater that once stood at this spot on 8 December 1881, shortly before a performance of Offenbach's opera "The Tales of Hoffmann", a fault in the electropneumatic ignition system for the gas lighting started an appalling fire. The number of dead was estimated at over 400. In identifying the corpses the forensic doctor **Eduard von Hofmann** – under whom Viennese forensic medicine achieved a leading position in the world – used modern methods such as examining the teeth of the victims. The charred head of a victim of the Ringtheater fire is still kept today in the Museum of Forensic Medicine in Vienna and a further one is exhibited in the Crime Museum in the Leopoldstadt. Hofmann's suspicion that in many cases the victims of a fire die through poisoning by smoke rather than burning could be proved through these corpses. He also succeeded in proving the existence of carbon monoxide in the blood of the victims. For forensic medicine this was a most important discovery. In the case of a murder after which the body of the victim is burned it could now be proved that, if there was no carbon monoxide in the blood, the victim had already been dead before being burned, or, on the other hand, if CO was found in the blood then this showed that victim had been burned while still alive. This catastrophe brought with it a new awareness, not just for the field of forensic medicine. In addition to changes to the building regulations concerning theatres and opera houses – the fire curtain and emergency lighting became compulsory items, and since then entrance

43

doors always have to open outwards – the shock caused by this disaster led to the establishment of the "Wiener freiwillige Rettungsgesellschaft" (Viennese Voluntary Rescue Society). The Ringtheater was not rebuilt after the fire and the **Emperor Franz Joseph** had the "**Sühnhaus**" (Expiation House), which he financed from his private purse, built in its place. The income from this tenement house was to be donated for all eternity to charitable foundations. **Sigmund Freud** lived and had his practice here from October 1886 to September 1891. The famous couch that he was given by a grateful patient originally stood in his newly opened practice in this building. He later took it with him to Berggasse and then to London where it can still be seen today. In the Second World War the imperial foundation building was heavily damaged by a bomb and was demolished in 1951. The Bundespolizeidirektion (Federal Police Headquarters) has stood here since 1974.

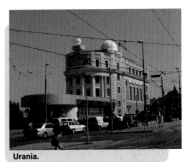

Urania.

Stock Exchange, Ringturm, Urania

Past the **Viennese Börse** (Stock Exchange) with its cladding of terracotta tiles the tram brings us to Vienna's first "skyscraper" – the **Ringturm** built between 1953 and 1955 which is 20 storeys tall and thus the highest building on the Ringstrasse. There is a 20-metre high "light column" on the roof that is directly connected with the oldest meteorological service in the world, the Hohe Warte in Vienna Döbling and that shows the weather forecast with 17 lamps. A panel explaining the system of differ-

ent lamps used for the weather forecast is to be found in the Underground station Schottenring. At the Ringturm the tram turns to the right into Kaiser-Franz-Joseph-Kai, which it now follows as far as Stubenring. The trip along the Kai (quay) is more interesting from a gastronomical than from a medical historical viewpoint. In addition to many restaurants and cafes, one of Vienna's most popular ice-cream parlours is located on Schwedenplatz. After Schwedenplatz, and shortly before the tram again turns right into the Ring, all eyes should look to the left where one can see the **Urania**, the oldest public observatory in Vienna, erected in 1909, and, in the distance to the left, the main attraction of the Viennese Prater, the Riesenrad or Giant Wheel. A short distance further on to the right of the observatory and again somewhat off the Ring is the building of the Viennese Rescue and Emergency Headquarters with a bust of Jaromir Mundy. Until well into the second half of the 19th century Vienna had no organised system of transporting the sick. The doctor **Jaromir Mundy** (1823 – 1894), who had already organised transports of the wounded on a number of differ-

Headquarters of the Viennese Medical Rescue Services.

services that made them change their mind. On 9 December 1881, only one day after the fire, Baron Mundy with his friend Count **Hans Wilczek** and Count **Eduard Lamezan** set up the "Wiener Freiwillige Rettungsgesellschaft" (Viennese Voluntary Rescue Society). Mundy collected the money required to finance the society through donations, collections and benefit events. **Johann Strauß the Younger** composed the march "Freiwillige vor" especially for a charity ball organised by the rescue society. The famous surgeon **Billroth**, a friend of Mundy, also supported the society – not only financially. Mundy who had suffered for a long time from manic depression shot himself in 1894 beside the Danube Canal. His death mask with the bullet hole in the right temple is in the Museum of the Viennese Rescue Services. At the headquarters building, no. 1 Radetzkystrasse, a bust commemorates the "greatest practical humanist

ent battlefields, wanted to set up a rescue service in Vienna. The authorities, however, showed no interest. It was the catastrophic fire in the Ringtheater and the complete failure of the emergency

Banking hall of the Postsparkasse.

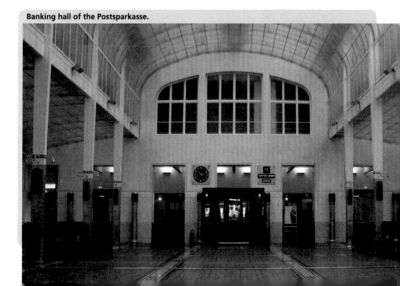

of our century" as Billroth called him. The Viennese rescue services were copied throughout the world.

Stadtpark, Schwarzenbergplatz, Hochstrahlbrunnen, Opera

From Stubenring the tram travels to Parkring, on the left is the imposing façade of the former War Ministry, to the right, set back from the road behind an area of grass, is a masterpiece of Viennese Jugendstil, **Otto Wagner's** Postsparkassenamt, which is well worth visiting. Beyond the old War Ministry on the left we travel past the Museum of Applied Arts and come to **Stadtpark** where a gilded statue of Johann Strauß forever plays his violin. The tram then brings us to **Schwarzenbergplatz** on Schubertring. The **Hochstrahlbrunnen** (fountain) on the left at the back of the spacious square that is Schwarzenbergplatz recalls the completion of the 1st

Pharmacy "zum Heiligen Geist".

Viennese mountain spring water supply. A report published by the Society of Physicians – Vienna's hygiene conscience, as it were – played a influential role in the provision of this water supply, which started operation on 24 October 1873. Thanks to the fresh water supply the number of deaths caused by typhus in Vienna sank from 1,149 in 1871 to only 185 a few years later. From Schwarzenbergplatz to the Opera House, where we finish our tour around the Ring, it is only one more stop.

Naschmarkt

If you wish to end this tour with a culinary highpoint, it is worth your while to visit the Vienna **Naschmarkt** only a short distance away. If we wish to continue our focus on medical history the most fitting way to reach the Naschmarkt is by going up Operngasse, which lies to the west of the Opera House. Here the name of the pharmacy at the corner of Operngasse and Nibelungengasse recalls the former Heiligengeistspital (Holy Ghost Hospital) that was then outside the city walls. In this hospital on 12 February 1404 the first anatomical dissection of a corpse in German-speaking Europe was carried out. As only those who had been executed could be dissected few dissections were carried out. Between 1404 and 1498 only 14 dissections were recorded in Vienna.

The surgeon and medical historian **Leopold Schönbauer** reports on a remarkable event from the year 1492: "in the case of the hanged thief Konrad Praitenauer, whose corpse had

been given to the faculty for dissection, signs of life were discovered, a vein was opened whereby foam issued from the mouth. Although according to Hippocrates this is a sure sign of death further efforts were made (to revive him) that finally met with success. The Vienna "Lektor" very much wanted to have him killed but was prevented from doing so" – at the time the university enjoyed the right of asylum – "Praitenauer was brought to his native town of Altötting at the expense of the faculty and lived there for a number of years before he was finally hanged, this time however properly."

Somewhat further on we come to the original exhibition building of the Viennese **Secession movement** designed by **Joseph Maria Olbrich**. At the end of 1890 a group of Viennese artists who rejected conservative historicism assembled here. Today visitors can admire Gustav Klimt's famous Beethoven Frieze in the basement. Just past the "goldenes Krauthappel" (gilded head of cabbage), as the building was popularly known by the Viennese, we can immerse ourselves in the indescribable world of the Vienna Naschmarkt where all our sense are beguiled.

Art History

Opera House

1st District, Opernring 2
Tel.: +4-1-514442250
Tickets: +43-1-5151315
Tours: see times on the homepage
Information: +43-1-514442606
www.wiener-staatsoper.at

Romanticist-historicist building by architects Eduard van der Nuell and August von Siccardsburg. However these two architects did not experience the grand opening with Mozart's *Don Giovanni* on 25 May 1869. Negative comments and criticism of the building drove van der Nüll to commit suicide and shortly afterwards Siccardsburg died "of a broken heart". The fire that followed an aerial bomb attack in 1945 destroyed the Opera House almost completely. Important personalities from throughout the world attended the reopening of the renovated building on 5 November 1955 at which Beethoven's *Fidelio* was performed.

Maria Theresien-Platz

1st District
www.mqw.at

Imposing monument to Empress Maria Theresia on which Kaspar von Zumbusch worked from 1874 to 1887. The museum complex around Maria Theresien-Platz was completed in 1891. The collections of the Imperial House that had been scattered throughout Vienna were brought together in these museums. The two museum buildings, which externally are mirrored reflections of each other, were designed by Gottfried Semper and Carl von Hasenauer.

Since 2001 Vienna's new Museumsquartier (7th District, 1 Museumsplatz) has been located to the south of this square in what was once the Court Stables complex. It contains the Leopold Museum (Schiele, Klimt, Kokoschka, Kubin to mention only a few of the artists) and the Museum of Modern Art, Ludwig Foundation (Viennese Actionism, Photorealism, Pop Art, Oldenburg, Rauschenberg and many others).

Kunsthistorisches Museum
Museum of Art History

1st District, Burgring 5,
entrance: Maria Theresien-Platz
Tel. +43-1-52524-0
info@khm.at
www.khm.at
Opening hours:
Tuesday to Sunday: 10am – 6pm
Thursday: 10am – 9pm

One of the oldest and most important art collections in the world.

Naturhistorisches Museum

1st District, Burgring 7,
entrance: Maria Theresien-Platz
Tel.: +43-1-52177
Opening hours:
Thursday to Monday: 9am – 6:30pm
Wednesday: 9am – 9pm
www.nhm-wien.ac.at

The core of the museum collection was formed by the imperial "Naturalienkabinette" (cabinet of natural objects) and the collections of astronomical instruments that date back to Rudolf II and the estate of Prinz Eugene of Savoy. The collections grew considerably under Emperor Franz Stephan I through material brought back from expeditions and purchases. This collection, once the largest natural history collection in the world, was housed in the Hofburg until the building of the new museum and has been open to the public since 1750.

Monument to the Republic

1st District, Dr. Karl Renner-Ring,
Schmerlingplatz

This monument that was unveiled in 1928 consists of the busts of Jakob Reumann (by Franz Seifert), Viktor Adler (by Anton Hanak) and Ferdinand Hanusch (by M. Petrucci) and commemorates the setting up of the Republic on 12.11.1918. It was taken down in 1934 under the Dollfuss regime and was reinstated on 12.11.1948.

Parliament

1st District, Dr. Karl Renner-Ring 3
Tel.: +43-1-401102715
For times of guided tours see the homepage.
www.parlament.gv.at

Erected to a Greek Revival design by Theophil von Hansen between 1873 and 1883. With numerous figures and reliefs by different sculptors. In front of the parliament building is the mighty Pallas Athene fountain, also designed by Hansen and made by Carl Kundmann that was erected in 1902.

Burgtheater

1st District, Dr. Karl Lueger-Ring 2
Tel.: +43-1-514444140
Tickets: +43-1-514444145
www.burgtheater.at

After the *Comedie française* the second oldest theatre for the performance of spoken drama in the world. Originally established in 1741 as the "Court and National Theatre" beside the Hofburg on Michaelerplatz. The first performance in the new "Hofburgtheater", which was designed by Gottfried Semper and Karl von Hasenauer in the years 1874–1878, was given on 14.10.1888. The building was conceived as a neo-Baroque contrast to the neo-Classical Parliament.

Rathaus / City Hall

1st District, Rathausplatz 1
Tel.: +43-1-52550
Guided tours: Monday, Wednesday, and Friday at 1pm, apart from holidays and during council meetings. Entrance from Friedrich-Schmidt-Platz.

Monumental neo-Gothic building reminiscent of the Town Hall in Brussels. Design and construction supervision by Friedrich von Schmidt (cathedral architect in Cologne and Vienna) between 1872 and 1883. The large

central arcaded courtyard is open to the public. The decorative sculptural and painting work was carried out by the leading artists of the time. At the top of the 98-metre high central tower is the 3.40-metre tall copper statue of the "Rathausmann" by decorative metal-worker Wilhelm Nehr which the Viennese master decorative metal-worker, Wilhelm Ludwig, donated to the council.

University

1st District, Dr. Karl Lueger-Ring 1
www.univie.ac.at

On 11 October 1884 Emperor Franz Joseph I opened the splendid main building of the New University designed by Heinrich von Ferstel in a Renaissance style and located on Vienna's new ceremonial boulevard the Ringstrasse. The core of the building is the Arkadenhof (arcaded courtyard), based on the idea of the Italian *campo santo*, with busts and monuments to important professors of Vienna University. At the centre of the Arkadenhof – the university's academic hall of fame – is the Kastalia fountain, as the "font of wisdom". The famous faculty paintings made by Klimt for the ceremonial hall raised such a storm of indignation in 1900 that Klimt bought them back and never again accepted a public commission. The paintings were lost in a fire in a castle in Lower Austria at the end of the Second World War. In the entrance hall of the Leopold Museum in the Museumsquartier (7th District, Museumsplatz 1) large-scale photographs of these "scandalous" paintings are displayed.

The rear of the university building is occupied by the library with an impressive reading room that is well worth seeing. The constant growth in the numbers of students has meant that many of the university institutes have had to be moved out of the main building.

Votivkirche Church "Zum göttlichen Heiland" Votive Church of The Divine Redeemer

9th District, Rooseveltplatz

The Votivkirche (Votive Church), which was erected out of gratitude for the failure of an attempt made on the life of Emperor Franz Joseph I in 1853, was designed in the French Gothic style by Heinrich Ferstel between 1856 and 1879. This historicist religious building, which stands on a former military exercise and parade ground, was the first building of the new Ringstrasse. The façade and interior have rich sculptural work by a number of artists from the period. The only truly Gothic artwork in the church is the upright tombstone of Count Niklas von Salm, the defender of Vienna during the first Turkish siege in 1529, which dates from 1530 and originally came from the secularised Dorotheerkloster (monastery).

Urania

1st District, Uraniastrasse 1
Tel.: +43-1-7126191-0
office@urania-wien.at

Impressive freestanding building designed in 1909/10 by Max Fabiani, a student of Otto Wagner, on a wedge-shaped site beside the Danube Canal. It contains an adult education centre with theatre (since 1920 a cinema), observatory and electronic central clock. The first official tour of the observatory was given on 6.6.1910 – before the formal opening ceremony – on the occasion of the appearance of Halley's comet.

Postsparkassenamt

Post Office Savings Bank
1st District, Georg Coch-Platz 2
Opening hours: Monday to Friday
8am – 3pm; Thursday until 5:30pm.

The Postsparkassenamt designed by Otto Wagner in an emphatically functional, sober and yet elegant style is one of the most important buildings of Viennese Jugendstil. This cubic building that glints in the sun due to its 17000 aluminium bolt heads – which are not decorative but were used to fix the marble cladding panels – represents a magnificent final highpoint of Ringstrasse architecture. Built between 1904 and 1906 and extended between 1910 and 1912 this Secessionist style edifice shows how perfectly functionality, aesthetics and beauty can harmonise with each other. The famous banking-hall with its coolly functional atmosphere has been largely preserved intact, as have the furniture and fittings that Wagner designed for the building. This iconic work of Viennese architecture is internationally recognised as an important contribution to the development of modern architecture in the 20th century.

Wagner Werkmuseum Postsparkasse

Tel.: +43-1-53453–33088
Email: museum@ottowagner.com
www.ottowagner.com

Museum shop
Media room (films about the Postsparkasse and Otto Wagner)

Opening hours:
Monday, Tuesday,
Wednesday and Friday: 8am – 3pm
Thursday: 8am – 5:30pm
Saturday: 10am – 5pm
Closed on 8 and 26 December

Secession

1st District, Friedrichstrasse 12
Tel: +43-1-5875307
www.secession.at
Opening hours:
Tuesday to Sunday: 10am – 6pm
Thursday: 10am – 8pm

Guided tours every Saturday at 3pm and Sunday at 11am as well as by appointment. Tours in foreign languages are also available.
Information: office@secession.at
Tel.: +43-1-5875307-11

The exhibition building of the "Secession" a Viennese artists' association that split in 1897 from the more traditional "Künstlerhaus" society, was designed by Joseph Maria Olbrich and is one of the jewels of Viennese Secession style. The most striking detail of this temple to art that was opened in 1898 is the filigree dome of bay leaves made of gilded iron that crowns this cubic (and largely windowless) building. The dome was given the nickname "goldenes Krauthappel" (golden head of cabbage) by the Viennese. Members of the Secession such as Othmar Schimkowitz, Kolo Moser and Gustav Klimt worked on the artistic decoration of the building. In the basement visitors can see one of Gustav Klimt's most famous works – the 34-metre long Beethoven Frieze.

Restaurants

Cafés

☕ Café Schottenring

1010 Vienna, Schottenring 19
Tel.: 315 33 43
Monday to Friday 6.30am to 11pm, Saturday,
Sunday and holidays 8am to 9pm

☕ Café Schwarzenberg

1010 Vienna, Kärntner Ring 17
Tel.: 512 89 98-13
Monday to Friday, Sunday 7am to 12 midnight, Saturday 9am to 12 midnight

☕ Café-Restaurant Mozart

1010 Vienna, Albertinaplatz 2
Tel.: 241 00-211
Daily 8am to 12 midnight

☕ Café Bar Restaurant Urania

1010 Vienna, Uraniastrasse 1
Tel.: 713 30 66
Monday to Saturday 9am to 2am,
Sunday 9am to 12 midnight

Inns and restaurants

🍴 Restaurant Hansen

1010 Vienna, Wipplingerstrasse 34 (Börse)
Tel.: 532 05 42
Monday to Friday 9am to 9pm

🍴 Appiano – Das Gasthaus

1010 Vienna, Schottenbastei 4
Tel.: 533 61 28
Monday to Friday 11am to 12 midnight
Meals served from 11am 3pm and from 6pm
to 10pm

🍴 Cantina e l'arte

Italian cuisine
1010 Vienna, Dr.-Karl-Lueger-Ring 14
Tel.: 05 05 05-41490
Monday to Friday 4pm to 11pm

🍴 Indochine 21

1010 Vienna, Stubenring 18
Tel.: 513 76 60
Daily 12 noon to 3pm and 6pm to 12 midnight

🍴 Restaurant Vestibül

1010 Vienna,
Dr.-Karl-Lueger-Ring 2 (Burgtheater)
Tel.: 532 49 99
Monday to Friday 11am to 12 midnight
Saturday 6pm to 12 midnight

🍴 Österreicher im MAK. Gasthaus.Bar

1010 Vienna, Stubenring 5
Tel.: 714 01 21
Daily 10am to 2am

Tour 4

Through the
Old General Hospital

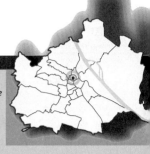

Tour 4

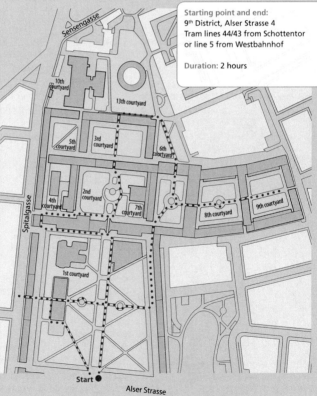

Starting point and end:
9th District, Alser Strasse 4
Tram lines 44/43 from Schottentor
or line 5 from Westbahnhof

Duration: 2 hours

Sensengasse

Spitalgasse

10th courtyard

13th courtyard

5th courtyard

3rd courtyard

6th courtyard

4th courtyard

2nd courtyard

7th courtyard

8th courtyard

9th courtyard

1st courtyard

Start ●

Alser Strasse

A walk through the Old General Hospital in Vienna is like taking a trip through over two hundred years of the history of Viennese medicine. Monuments, busts and memorial plaques in the courtyards of this former "city of the sick" recall great medical achievements that shook the foundations of the established medical world-view and, in fact, altered the world of medicine.

Former main entrance,
"To heal and Console the sick"

If as a tourist one is visiting the old Allgemeines Krankenhaus (Old General Hospital) in Vienna for the first time then the right way to do things is to use the small former main entrance to the

Former main entrance to the Old General Hospital.

hospital at no. 4 Alser Strasse, rather than one of the new entrances in the southeast or southwest of the 1st courtyard. But first of all let us gain an overview of the complex from the far side of the road. Apart from the modestly decorated **former main entrance** the long wing in front of us is very plain and unadorned. And yet with this General Hospital in Vienna **Emperor Joseph II**, the son of Maria Theresia, placed himself a monument in 1784 that, measured in terms of its humanitarian usefulness, does not just easily compete with the most splendid cathedrals, the most imposing temples and the most impressive pyramids in the world but in fact outdoes them. The inscription "Solutio et solatio aegrorum" (**"To heal and console the sick"**), which the emperor had placed over the main entrance to this huge complex, was for him not a platitude but the motto of his entire philanthropic attitude. Based upon the model of the Parisian central hospital "Hotel Dieu" the emperor had the Grossarmenhaus (Great Poorhouse) that had existed here since 1693 converted into the Allgemeines Krankenhaus (General Hospital). This institution with 2000 beds was ceremonially opened on 16 August 1784, after a planning and construction period of only three years. A further figure would probably cause hospital managers today to leap with joy: for all the clinics of this huge hospital only 20 doctors and surgeons and 140 attendants (male and female) were required. With its 2000 regular beds the General Hospital in Vienna was at that time one of the largest hospitals in the world.

In the barrel, vaulted main entrance a memorial plaque erected to commemorate the hospital's 150th anniversary informs us briefly about its history. A further plaque states that the City of Vienna donated the entire site to the University of Vienna in 1988 and thus, for the first time in its existence, the university had a university campus, something that had been planned at its founding in 1365 but never created.

Theador Billroth

Let us now enter the extensive 1st courtyard (1. Hof) where we find ourselves directly opposite a larger than life-size statue of one of the giants of operative medicine: **Theodor Billroth** (1829 – 1894), who achieved world renown through his daring new operating techniques.

In 1867 Billroth moved into the 1st courtyard of the General Hospital. The operating theatre, lecture hall and clinic were in the north-western corner of the 1st courtyard, above the passageway leading to the 2nd courtyard, and it was here that Billroth wrote medical history: the first esophagectomy in 1871, the first laryngectomy in 1873 and, finally, in 1881, after ten years of preparation, the operation that today still bears his name: the first successful excision of a cancerous pylorus. After all the technical details had been clarified by operations on animals he and his staff examined 61,287 autopsy reports to discover how many patients had died of a carcinoma of the pylorus without metastases. When the percentage turned out

Theodor Billroth Monument.

to be 41.1 per cent Billroth decided to attempt the operation.

After a waiting period of five years the first patient suitable for a resection, the 43-year-old **Therese Heller**, arrived at the clinic. On 29 January 1881 Billroth carried out on her the first successful gastric resection in the world. The operation specimens and the post-mortem specimens – the patient died three months later with metastases of the liver – are today in the Museum of the History of Medicine in the Josephinum. In 1885 he described a second method of gastric resection today generally known as "B II" – Billroth II. Billroth also discovered and isolated a kind of bacteria, to which he gave the name still used today: streptococci. Unknowingly, with his demand for "cleanliness to the point of excess", Billroth anticipated the antiseptic sterile methods of operating. It

was **Louis Pasteur** (1822 – 1895) and **Robert Koch** (1843 – 1910) who were first able to prove that bacteria were the cause of infections and that they entered wounds by touch and not, as was originally thought, through the air. Thanks to this knowledge doctors gradually learned how to operate aseptically. Billroth's remarks a few years before his death sound almost wistful: "All surgeons now wear the antiseptic uniform, the individual is moved into the background. With clean hands and a clean conscience the most unpractised surgeon will now achieve better results than formerly the most famous professor of surgery." The training of nursing staff was one of Billroth's particular concerns as he recognised that only good post-operational care could ensure the success of his operations.

2nd Ophthalmic Clinic

Before we leave Billroth let us turn around briefly. The 2nd Ophthalmic Clinic was once located on the first floor above the main entrance. A pioneering discovery, not only for the field of ophthalmic medicine but also for medicine as a whole, was made out by a minor secondary doctor in this **2nd Ophthalmic Clinic**. On 5 July 1884 **Karl Koller** (1857 - 1944) removed a foreign body from an eye in a manner that differed from the usual practice. He removed it without causing any pain after putting drops of a 2% cocaine solution in the eye. His report, which he had read to the 16th meeting of German ophthalmologists on 15 September 1884, was a medical sensation. From this time on

it was possible to operate painlessly on the eye. Soon the procedure was successfully used in other specialised areas also. "Coca-Koller", as Sigmund Freud, who had drawn Koller's attention to cocaine called him, became the founder of local anaesthesia.

Johann Peter Frank, Rokitansky

Let us now leave Billroth and wander along the wide avenue into the 1st courtyard. On the right-hand side we notice a column on which an inscription and two rusted bolts recall a bronze bust that was once fixed here: the bust of **Johann Peter Frank** (1745 – 1821). It was stolen in the mid-1990s and has never resurfaced since. Frank was not the first director of this institute but one of the most important. The full ex-

Johann Peter Frank.

Memorial to Johann Peter Frank.

Medical School show much interest in the problems of poverty and issues of social medicine. It was only as a consequence of the industrial revolution that the ideas of Johann Peter Frank were revived. He is today regarded as the founder of prophylactic medicine, social medicine and hygiene.

Stöckl

From the very start the "General" was not only an institute for the care and treatment of the sick but also a centre of medical research and teaching. Despite all the reservations and objections to this huge central hospital the immense and varied "supply of illnesses" and the immediate proximity of the researchers to the sick people was ultimately responsible for the great success of the Viennese medical schools. The seat of the Medical University Clinic at the time was the freestanding building in the first courtyard known as the **"Stöckl"** building. Here, on the sec-

tent of his revolutionary ideas was realised only decades later. He increased the number of beds in the university clinic and secured patients who could be used for instructional and teaching purposes from the large "supply" in the General Hospital. Frank was primarily an eclectic who collected valuable ideas from all the dominant medical systems of the time, examined them critically and then taught them. Frank placed great emphasis on knowledge of pathological anatomy. He organised the establishment of an independent department of pathology, the appointment of a prosector and the building up of a pathological-anatomical museum. A generation later, under **Carl von Rokitansky** (1804 – 1878), the Second Viennese Medical School was to develop from this pathological institute. At the beginning of the 19th century the state showed little interest in the welfare of the common people, nor did the representatives of the Second Viennese

Stöckl, former University Clinic.

ond floor, the medical and surgical university clinic was located from 1784 to around the middle of the 19th century. It consisted of a lecture hall, a library, an operating theatre and four sick rooms, each with six beds.

Franz Schuh

Now we leave the direct path, we turn to the left passing a decorative fountain,

continue through the Stöckl building and, after the passageway, take a turn to the left. At the end of the building stands the bust of the surgeon and Billroth's predecessor: **Franz Schuh** (1804 – 1865). Franz Schuh linked physical diagnostics, which **Joseph Skoda** perfected for the field of internal medicine, with surgery, which had previously been conducted as a kind of craft. Through touching, tapping and listening to the chest as well as the belly, Schuh was able to show how valuable the physical examination could be for surgery also. In 1840 after making a precise physical examination of the female patient he ventured upon the first puncture of pericardoperation and on 28 January 1847 was the first surgeon on the European continent to carry out an amputation on a patient who had been put into a state of "ether intoxication".

Let us return to the avenue in the centre of the 1st courtyard. The fountain at the centre of the path commemorates the connection of the hospital to the 1st Vienna mountain spring water supply system in 1885. As a result the number

Bust of Franz Schuh.

Fountain in the 1st courtyard.

of deaths due to typhus in the hospital sank by the almost unbelievable figure of 90 per cent. After a memorial stone for those doctors who died in the First World War we find ourselves in front of the hospital chapel under which a pas-

Former surgical department.

sageway leads to the 2nd courtyard. Johann Peter Frank and later **Ignaz Semmelweis** (1818 – 1865) were annoyed by the chapel bell that was rung each time a patient died. They did not believe the almost permanent ringing was exactly conducive to their patients' wellbeing. Tour 5 deals with Semmelweis at greater depth. However now we do not go through the passageway leading to the 2nd courtyard but turn to the left where a memorial plaque commemorates the much-loved (and equally wellfed) surgeon **Leopold Schönbauer** (1888 – 1963). In the final days of the Second World War through his courageous actions Schönbauer protected the General Hospital and his patients from the dangers of war.

At the end of this wing, in the corner above the passageway leading to the 4th courtyard, we should take a respectful look upwards: here as one can still see from the different sizes of the windows, the lecture hall and operating theatre of Theodor Billroth were once located. The

Hexagon in the 1st courtyard.

Operation bunker from the 2nd World War.

small green hexagonal wooden hut in front of the powerful former operation bunker – today the cold-storage depot and kitchen of the beer bar – on the left hand side recalls an amusing procedure that one could observe in days gone by: the nuns who worked as nurses in the General Hospital lived in a building known as the Nonnenhaus (nuns' house) on the far side of Spitalgasse. As they were not allowed to or did not want to walk around in public an underground tunnel connected the convent with the 1st courtyard in the General Hospital. The exit from this tunnel was in the small wooden building. And so every morning, when the nurses started work, observers could watch a unique spectacle. Out of the tiny hut, one after the other, numerous nuns emerged in full habit with beautifully starched, fluttering white veils.

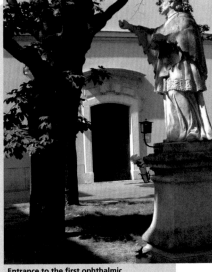

Entrance to the first ophthalmic clinic in the world.

1st Ophthalmic Clinic

Through the gateway we enter the 4th courtyard. Immediately past the exit to Spitalgasse we find ourselves standing in front of the original Baroque entrance doorway to the **first ophthalmic clinic** in the world. Today it is the entrance to the Institute for Islamic Studies. **Georg Joseph Beer** (1763 – 1821), the founder and first director of the clinic, had run a private clinic and treatment centre since 1786 on Michaelerplatz in the inner city of Vienna where he treated poor people free of charge and in certain cases even looked after them at his own cost. From 1793 he was allowed to operate on impoverished patients in the General Hospital in May and June, months that were regarded as particularly suitable for operations. In 1812 he was asked to open a clinic for eye diseases in the General Hospital and also to be its director. Although the clinic consisted only of three rooms – two sick rooms each with nine beds and lecture hall that was also used as an operating theatre – it was nevertheless a sensation for the personal physicians of the crowned heads who attended the Congress of Vienna in 1814/15. In 1818 Beer was finally appointed professor and the subject of ophthalmology was made obligatory in Vienna. A large number of students helped to spread his life's work. Beer's manual of ophthalmology was for a long time the bible, as it were, of ophthalmologists.

In front of the former entrance to the Ophtalmic Clinic stands a Baroque statue of St.John Nepomuk who is usually a patron saint invoked in times of flooding, reminding us that the Alserbach (Alser stream) still flows beneath Spitalgasse and Lazarettgasse, albeit much tamed. Leaving the fine Baroque saint on our left we enter the **2nd courtyard**. In the middle of this courtyard is an imposing statue of Joseph II and to the right of it a Japanese stone garden that was made to mark the 60th anniversary of the subject of Japanese studies at the University of Vienna. A simple commemorative plate on the north side of the courtyard, at an angle to the right behind the stone garden, recalls the founder of scientific dermatology in Austria: **Ferdinand von Hebra** (1816 – 1880).

Ferdinand von Hebra.

From the establishment of the General Hospital onward those with scabies, leprosy and all kinds of skin diseases were put in what was called the rash or eruption room. The patients were left more or less to the care of the attendants and the authorities were happy to separate them from the other patients. The changes in the skin were interpreted as "flowers" and "buds", that is the erup-

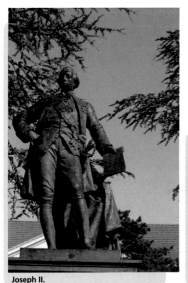
Joseph II.

Memorial plaque to Ferdinand von Hebra.

tion of a disease alive in the body. To try and remove the incrustations on the skin by any form of treatment was regarded as highly dangerous. It was believed that the body was attempting to cleanse its impure mixture of blood, bile and mucus in this manner.

Hebra made the breakthrough by proving that scabies, then one of the most common skin diseases, was in fact caused by mites. Scabies had been long regarded as an infectious disease caused by a foul mix of fluids, which led to psoric dyscrasia. Although it was known that in cases of this disease a small animal, the scabies mite, was regularly found, it was believed that the mite developed through abiogenesis, as it were. By experimenting on himself – he placed living mites on his skin – Hebra was able to prove that scabies was caused by a parasite. One dogma of the theory of bodily fluids had been disproved. His publication "über Krätze" ("About Scabies") that appeared in

1844 was a scientific sensation. Skin diseases were no longer seen as eruptions but as diseases of a bodily organ, the skin. From this time on there was no more fear of treating skin diseases therapeutically. Hebra began to treat local changes in the skin with local means. He introduced a series of effective tar, quicksilver, zinc and sulphur preparations into the field of dermatology and invented the waterbed for the treatment of burns.

Central X-ray Institute

Through the gateway on the left of the memorial plaque we enter the 3rd courtyard, formerly the kingdom of the diagnostic interpreters of shadows. Here was once the world famous **Central X-ray Institute** of the General Hospital that took up almost the entire ground floor. The history of the x-ray was made here, and here is where the beginnings of radio-diagnostics and therapy lie. The first press reports about this "sen-

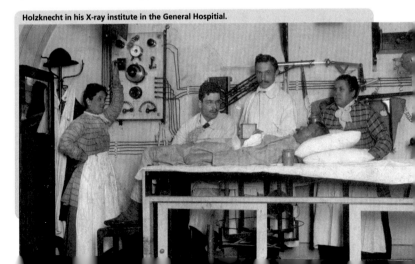

Holzknecht in his X-ray institute in the General Hospitial.

sational discovery" appeared on 5 January 1896 in a Viennese newspaper, before **Wilhelm Conrad Röntgen** officially disclosed the discovery of x-rays. The first diagnostic use of x-rays by **Gustav Kaiser** (1871 – 1954) on 14 January 1896 and also the first therapeutic use by **Leopold Freund** (1848 – 1943) in November 1896 took place in Vienna. Unfortunately the first doctors to lose their health (some of whom even lost their life) due to damage by x-rays, were radiologists who worked in Vienna.

Guido Holzknecht

One of these, who has entered the history of radiology as a martyr to his profession, was **Guido Holzknecht** (1872 – 1931). Even before his graduation he began to work in the 1st Medical Clinic

Guido Holzknecht.

under **Hermann Nothnagel** (1841 – 1912) and to attend the x-ray courses given by Gustav Kaiser. Under Kaiser who unjustly is almost entirely forgotten today, the x-ray laboratory of the 2nd Medical Clinic developed into the birthplace of medical radiology in Austria. Out of Kaiser's laboratory developed the "Röntgenzentrale des Allgemeinen Krankenhauses" (X-ray Centre of the General Hospital) in 1898, which was the core of the later famous Zentralröntgeninstituts der Universität Wien (Central X-ray Institute of the University of Vienna).

Holzknecht was so fascinated by the diagnostic possibilities offered by the new x-rays that he installed an x-ray machine in the Nothnagel clinic in 1899 that he financed himself. In the so-called "plague chamber" where, a year earlier, the laboratory attendant Franz Barisch had died of laboratory plague, he examined patient after patient in a tiny space and under difficult circumstances. His first book "Die röntgenologische Diagnostik der Erkrankungen der Brusteingeweide" (Diagnosis by Radiology of Illnesses of the Internal Organs of the Chest) appeared in 1901, a standard work of radiological diagnosis of the thorax.

The pioneers of radiology were not completely aware of the damaging effects of the ionising rays. However it was soon recognised that the damage done to the skin was related to the amount of radiation. Holzknecht was the first to construct an appliance to measure the amount of radiation given off: the

chromoradiometer. With this simple appliance that he introduced in 1902 it was possible to reduce the amount of radiation damage in his department by almost 90 per cent. At the same time as Leopold Freund und **Robert Kienböck** (1871 – 1953) Holzknecht was appointed assistant professor for medical radiology in 1904. This meant that, despite the resistance of the faculty, radiology was recognised as an independent medical discipline.

Under Holzknecht a school of radiology developed that achieved world renown. Due to the numerous scientific publications the "Röntgen-Zentrale" achieved an excellent international reputation. Foreign radiology associations organised trips to Vienna to allow students to study at the place where Holzknecht worked. They often expressed surprise that research results of this kind were possible under such "primitive conditions".

It was at this time that radiation damage began to appear in Holzknecht's hands. Numerous x-ray examinations – protection against the rays was unknown in the early days of radiology – had led to radio-dermatitis and to x-ray cancer. The first amputation of a finger was carried out in 1910, numerous operations on his hands and arms followed. Holzknecht bore this martyrdom with a stoical equanimity. He even had specially shaped arm prostheses made so that he could continue to research. After decades of suffering Holzknecht died on 31 October 1931, having undergone sixty-

Former Pathological Institute on Spitalgasse.

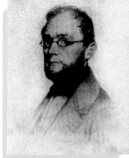

Carl von Rokitansky. **Rokitansky's former workplace.**

four disfiguring operations. A life-size bronze bust in Arne Karlsson Park – at the corner of Spitalgasse and Währing-erstrasse – commemorates this pioneer and martyr of radiology.

Pathological Institute

If we leave the 3rd courtyard through the northern gateway straight ahead of us we find ourselves in front of the most impressive building of the General Hospital, known as the Narrenturm (literally tower of fools). However we divert our gaze and first of all take a look to the left. Here stands the former **Pathological Institute** in which **Carl von Rokitansky** (1804 – 1878) attempted to clarify the causes and nature of sickness through anatomical examination. Rokitansky's goal was to show how the "facts can be used for the diagnosis of the living". He achieved this through his collaboration with the internist **Joseph Skoda** (1805 – 1881). Skoda compared the reports that he had made through tapping and listening to live patients with the autopsy reports on

the corpses. In this way he could discover the relationship between clinical observation and the anatomical report. Symptoms were no longer merely accidental but were externally visible signs of the organs' inner activity. It was not only internal medicine but also surgery, dermatology and obstetrics that profited from the gigantic amount of material that Rokitansky collected in his autopsies. His work established clinical medicine on a solid physical and anatomical basis.

Karl Landsteiner

Under the "triumvirate" Rokitansky, Skoda and Hebra Vienna became a world centre of medicine. Foreign doctors and students flocked to Vienna. There was something to be learnt there and something to be seen that one would look for elsewhere in vain. Rokitansky was famous throughout Europe when his new institute building was erected in 1862. A memorial plaque on the west side of the institute commemorates another great medical

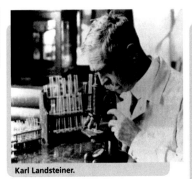

Karl Landsteiner.

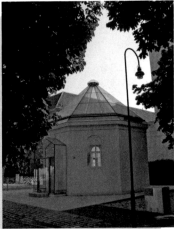

Synagogue: artistically designed memorial space.

achievement in this institute building on Spitalgasse. It was here that **Karl Landsteiner** (1868 – 1943) discovered the classic blood groups. For this pioneering discovery that made the transfusion of blood from one person to another possible, Landsteiner was awarded the Nobel Prize on 1930. As he was badly paid and received far too little funding for his research he had long left Vienna by that time, having followed a call to the Rockefeller Institute in New York. As the crowning achievement to his lifetime's work he discovered the Rhesus factor in 1941. The Centre for Brain Research

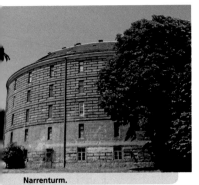

Narrenturm.

has been housed in this beautifully restored building since 2000.

We now turn to the right and, however difficult it may be, this time we do not pay a visit to the Narrenturm – the first institution for the "mentally ill" in Vienna. Emperor Joseph II financed this building, the most unusual and unique one in the General Hospital complex, out his own pocket, as it were, and it truly deserves a chapter of its own.

Schwangerentor

Past the former hospital synagogue in courtyard 6, which was destroyed in 1938, served as the transformer building of the hospital from 1955 and today has been transformed into an artistically designed memorial, we walk through the Peuerbach Gateway into the 7^{th} courtyard. Here on the left and occupying practically the entire eastern area of

Pläne des Gebärhauses vom Jahre 1784 ¹).

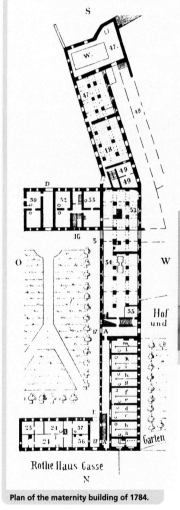

Plan of the maternity building of 1784.

Tafel I.

Parterre.

17. Eingang ins Gebärhaus
55. Aufseherin des Gebärhauses
56. Portier des Gebärhauses
57. Helferin
a—m 12 Extrazimmer für 12 täg-
 lich 1 fl. zahlende Schwan-
 gere und Kindbetterinnen
 (entsprechend a—m im Mez-
 zanin 11 Extrazimmer für
 11 täglich 1 fl. zahlende
 Frauen).

¹) Die Pläne sind dem Original
entsprechend verkehrt situiert.

Schwangerentor in the 7ᵗʰ courtyard.

yard, once known as the **"Schwanger-entor"** (pregnant women's gateway) and known today as the Holzknecht-tor, was the entrance. Here, on order of Joseph II women "with masks, veiled and as disguised as they wished" could come to the hospital and give birth anonymously. This courtyard also commemorates the obstetrician who established obstetrics in Austria as an independent subject and was a precursor of "natural" childbirth in Vienna: **Johann Lukas Boër** (1751 – 1835).

the courtyard was the hospital maternity building The gateway leading into the south-eastern corner of the court-

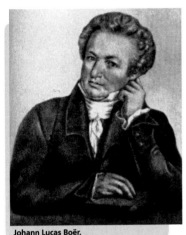

Johann Lucas Boër.

senal of blunt and pointed instruments was employed. "One might almost have believed that nature had given up her business in the matter of birth and left it up to the tools of the obstetrician", Boër remarked in this context. In England he got to know a more conservative approach to obstetrics. In France I learned what artifice, in England what nature can do." The English always remained Boër's great models.

In 1789 Boër took over the direction of the newly established department for poor mothers-to-be in the General Hospital. Joseph II had set up this department as a "place of refuge and rescue" for single mothers, where women could give birth anonymously. Anonymity was necessary to avoid the shame and discrimination that single mothers were exposed to at the time and that frequently led to infanticide.

Under Boër the Viennese school of obstetrics achieved world renown. He regarded light, air and good food for the weakened mothers-to-be as far more important than all the medication available in the apothecary. The administration of the hospital often complained that the food he prescribed for the pregnant women was far too rich and too good. His prescriptions often consisted only of a "glass of wine, some plum compote, with Epsom salts and a few spoons of tincture of rhubarb." He strongly rejected the use of bloodletting and purgatives as preparation for birth. He viewed birth as a physiological process that rarely required the assistance of a doctor. His motto was to

Through his work as a wound doctor in the orphanage and foundling house Johann Lucas Boogers (Boër's real name) came in contact with Emperor Joseph II who frequently visited the orphanage. The emperor liked the young doctor – regarding him I wish that he should devote himself to the study of birth and apply the diligence and care to this subject that it deserves on account of its importance. His personality is well suited to being an obstetrician, his talent and earnestness will supply the rest" – sent him to France and England to train in the area of obstetrics. Equipped with a barouche, travel money and recommendations. Boogers, who in response to a wish of the emperor – "as a concession to the Gallic tongue" – changed his name to Boër, started his trip in 1785. In Paris at that time the forceps, which had been in general use since 1723, was used extremely frequently and indeed at every opportunity an entire ar-

let the mother give birth to her child, and not to pull it out of her. He decided upon operative intervention only in the greatest emergencies. With Boër a new era of obstetrics began and he is now regarded as the founder of the "gentle birth" that today is discussed as heatedly as it was back then.

The maternity clinic in the General Hospital developed into an ideal training facility under Boër. The Viennese clinic became a kind of place of pilgrimage for doctors and midwives from many different countries. The students had the opportunity to attend births day and night and to learn from experienced midwives. Boër not only gave his students a theoretical basis but made practical obstetricians and midwives out of them. His "Abhandlungen und Versuche geburtshülflichen Inhalts" (Essays on the Content of Obstetrics) , appeared between 1791 and 1807 and were for a long time the gospel of those involved in childbirth.

Boër's successor **Johann Klein**, who entered medical history as the opponent of **Ignaz Semmelweis** who also worked in this department and made his decisive observations here, directed the "childbirth clinic" somewhat less successfully. The Viennese clinc quickly lost its importance. Foreign doctors came rarely and mostly only because one could study childbed fever so well here. Boër had a low rate of childbed fever. He did not stick to the teaching plan and let his students practice only on dummies and not on corpses. His successor, however, strictly followed

Hermann Franz Müller.

the plan laid down and deaths due to childbed fever rose dramatically.

Through the Piccolomini gateway we reach the 8th courtyard. Semmelweis' office, where he developed his pioneering ideas about the cause of childbed fever and finally was able to prove them was once located here. It was on the second floor in the long northern side of the 8th courtyard, and was reached from staircase 33. The tragic story of Ignaz Semmelweis is told in full in Tour 5. Let us now proceed to the 9th courtyard where there is a memorial to another martyr to his profession. The portrait bust of the internist **Hermann Franz Müller** (1866 – 1898), the doctor who treated the institute attendant **Franz Barisch** (who had infected himself with the plague through his own carelessness) and who himself fell victim to the laboratory plague. The nurse **Albine Pecha** and Hermann Müller died from lung plague in October 1898 hermetically isolated in the Kaiser Franz Joseph Hospital in Vienna. They were the last

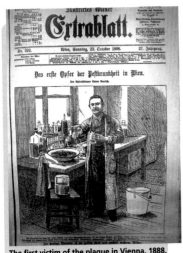

The first victim of the plague in Vienna, 1888.

all the lecture halls are also located is the 2nd courtyard. In the 1st courtyard, which is also used by the public, there are offices, shops, a supermarket, a children's play area and a number of restaurants (where students are not the only guests) in a park-like setting. We too should finish off our tour here in a relaxed way. However this does involve a certain danger as it could considerably lengthen the duration of the tour. The restaurants and bars on the campus stay open until two in the morning!

victims of the plague in Vienna. Interestingly it was in this chamber in the General Hospital, where Barisch died and Müller had personally disinfected the walls, that Guido Holzknecht set up his x-ray machne that his mother had financed. Holzknecht knew the story of this room. On a postcard with a depiction of Müller he wrote to his sister: "... a victim of his profession in the service of science". At that time he little realised that he himself was to enter the annals of medical history as a martyr to his profession.

From the 9th courtyard we walk back to the 1st courtyard where we end our stroll through the centuries. The Old General Hospital is today the University Campus and houses numerous institutes of the faculty of humanities and cultural sciences. The university centre where

1 Mariannengasse, Viktor Emil Frankl

Let us then finally leave the campus, hopefully with something of a heavy heart. We should make our exit through the Sigmund Freud gateway behind the Stöckl building. Not only because this reminds us of **Sigmund Freud** (1856 – 1939), who worked and researched in a number of departments of this complex, but also because directly after leaving we find ourselves in front of the building no. **1 Mariannengasse**. On the building on the far side of the street a memorial plaque recalls the founder of logotherapy and existence analysis: **Viktor Emil Frankl** (1905 – 1997). When they hear the name Frankl millions of people make the same association: the word "meaning". For Viktor Frankl meaning (logos) had the importance that lust held for Sigmund Freud, or power for **Alfred Adler** (1870 – 1937). For Frankl the main motivation in human life was the search for meaning. Frankl, who went through the hell of four concentration camps, experi-

the future, towards a meaning that they expected to be fulfilled in the future". The "will to meaning" as he called it, formed the "survival value". In 1955 he was awarded the title of professor of the University of Vienna. He achieved his fame, however, in America. Over nine million copies of his book "Man's Search for Meaning" have been sold and it is regarded in America as "one of the ten most influential books". His 32 books have appeared in 31 languages and the University of California set up a special chair for him. Visiting professorships in four American universities, 29 honorary doctorates, awards and honours show the esteem and recognition accorded to his scientific work throughout the world. After he was freed from the concentration camp in 1945 he lived in this house until his death. His former apartment now houses the archive of the Viktor Frankl Institute.

House in which Viktor Frankl lived.

enced personally that "among those who were not sent immediately to the gas chambers, the survivors tended to be people who were oriented towards

Restaurants

⑪ Universitätsbräuhaus

1090 Vienna, Alser Strasse 4
(Campus, Old AKH, 1ˢᵗ Hof)
Tel.: 409 18 15
Daily 9am to 2am

⑪ Stiegl Ambulanz

1090 Vienna, Alser Strasse 4
(Campus, Old AKH, 1ˢᵗ Hof)
Tel.: 402 11 50-0
Daily 11am to 12 midnight

⑪ Flein

1090 Vienna, Boltzmanngasse 2
(Corner of Währinger Strasse)
Tel.: 319 76 89
Monday to Friday 11.30am to 3pm
and 5.30pm to 12 midnight

⑪ Café-Restaurant Stein

1090 Vienna, Währinger Strasse 6-8
Tel.: 319 72 41
Monday to Saturday 7am to 1am,
Sunday and holidays 9am to 1pm

The New General Hospital
and the "New Clinics"

Tour 4

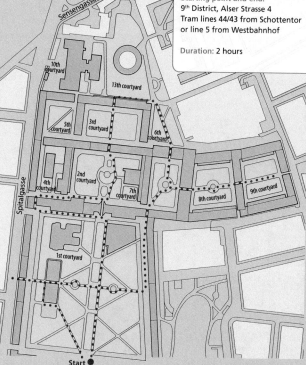

Starting point and end:
9th District, Alser Strasse 4
Tram lines 44/43 from Schottentor
or line 5 from Westbahnhof

Duration: 2 hours

Sensengasse

Spitalgasse

10th courtyard

13th courtyard

5th courtyard

3rd courtyard

6th courtyard

4th courtyard

2nd courtyard

7th courtyard

8th courtyard

9th courtyard

1st courtyard

Start ●

Alser Strasse

The best place to start this tour is at the U6 station *Michelbeuern,* where a footbridge leads us over to the two enormous towers of the General Hospital (Allgemeines Krankenhaus). The **AKH**, one of the biggest and most modern hospitals in Europe, was officially opened on 7 June 1994 after years of planning and construction that were riddled with various scandals. The dictum "Saluti et solatio aegrorum" ("To Heal and Comfort the Sick") above the entrance to the old General Hospital at no. 4 Alser Strasse, also stands at the entrance to the **new hospital**.

Almost twenty years before the twin patient towers were opened, what are known as the "Clinics in the South Garden" started operations. This complex that today comprises the university clinics of paediatrics, neuro-surgery, psychiatry and depth psychology opened its doors in 1974/75. There are four memorials to be seen here, dedicated to the doctors whose work in these specialised fields provided important impulses for medicine throughout the world.

The memorial in front of the psychiatric clinic commemorates one of the General Hospital's three Nobel Prize winners – **Julius Wagner-Jauregg** (1857–1940), the conqueror of progressive paralysis (Dementia paralytica). In 1927 he received the Nobel Prize for physiology and medicine for his discovery of malaria inoculation treatment for patients with progressive paralysis. This condition, a late stage of syphilis, was incurable at the time and led, among

Ward towers of the new AKH.

Julius Wagner-Jauregg.

other symptoms, to complete dementia and, after only a few years, to death. It was widespread in psychiatric institutions in the era before antibiotics. The discovery of penicillin in the 1930s and 40s led to malaria inoculation treatment being abandoned. One discovery made by Wagner-Jauregg still of benefit today was that goitre can be prevented by adding iodine to table salt. He had already proved the connection between iodine deficiency and goitre in a study of cretinism in 1889, but it was not until 1923 that Austria decided to add iodine to table salt.

A discussion over whether Wagner-Jauregg was worthy of an official grave of honour in Vienna's Central Cemetery (he was accused of association with the National Socialist Party, of spreading National Socialist ideas and concepts of "racial hygiene") led to an extensive investigation initiated by the State of Upper Austria in 2004, to examine the question of "whether the person after whom the state psychiatric hospital is named [Julius Wagner-Jauregg] should be seen as someone with a dubious history". The distinguished commission, consisting of a historian, a social scientist, a sociologist and psychiatrist came to the following conclusion: Wagner-Jauregg was at no time a member of the NSDAP (Nazi Party); although only few months before his death the German nationalist Wagner-Jauregg had for unknown reasons applied to join the NSDA but was refused "on the grounds of...race", as his first wife was Jewish. As for spreading the doctrine of racial hygiene, the commission saw this as his personal contribution to eugenics, which at the time was part of "the mainstream international scientific debate", and could find no "racial hygiene terminology" in the National Socialist sense in this work. The commission came to the conclusion that "Wagner-Jauregg should not be seen as a man with a dubious history".

The bust in front of the paediatric clinic portrays the paediatrician **Clemens von Pirquet** (1874–1929), who gave the world the term "allergy". Pirquet was an assistant to the well-known **Theodor Escherich** (1857–1911) in the University's paediatric clinic, at that time based in the St Anna's Children's Hospital, when in 1906 he first encouraged the use of the new term of "allergy", which has since passed into the realm of everyday language. In 1907, another great medical achievement, the tuberculosis test, brought Pirquet worldwide recognition. "Let us look with the naked eye at what happens to the skin of an 'immune' person when one injects

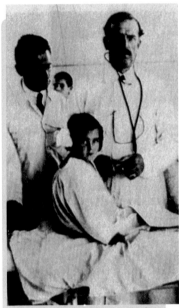

Clemens von Pirquet with a young patient.

The building known as the "New Clinics".

into it the infectious bacteria that the organism has already fought". This brilliantly simple method, whereby a few drops of tuberculin were placed with on an area of skin scored with the Pirquet needle, and the reddening of the skin recorded after 24 and 48 hours, meant that tuberculosis could be diagnosed at an early stage, without the need for x-rays. This discovery made the medical prevention of tuberculosis possible for the first time, and Pirquet regarded the cutaneous tuberculin test as the most important result of his research. Before succeeding his mentor Theodor Eschrich in 1911, Pirquet worked as professor for two years at the John Hopkins University in Baltimore. His good connections in America enabled him to organise the American Child Relief programme after the First World War, which ensured that up to 400,000 undernourished Austrian children could be fed on a daily basis.

In the anteroom to the lecture hall of university psychiatric clinic there are portrait busts of two psychiatrists who represented almost diametrically opposed schools – **Theodor Meynert** (1833–1892), and **Hans Strotzka** (1917–1994).

Like many other psychiatrists of the time, Meynert attempted to solve the riddle of psychiatric illnesses by research into the neural network of the brain. Although it was soon realised that this

the processes involved in the nerve fibres and tracts, Hans Strotzka was a pioneer in the field of psychosomatic medicine and investigated psychological influences on pathological-anatomical changes. In October 1971 Strotzka, educated as an conventional psychoanalyst but open to other forms of psychotherapeutics, took over the professorship of the newly created chair of depth psychology and psychotherapy at Vienna University.

Leaving the area of the new General Hospital we again immerse ourselves in the world of old medical Vienna. Passing alongside the two patient towers we arrive at what are known as the *Neue Kliniken* (**New Clinics**). It had already been agreed by the end of the 19th century that, even with massive redesign and modernisation, the old general hospital would be unable to meet contemporary demands. Consequently, on 21 June 1904 in the presence of **Emperor Franz Joseph I**, the laying of the foundation stone for the new clinics was carried out. Completion of the entire project – which was to consist of 20 large pavilions – was prevented by the two World Wars. The first building we come to on our right was once the 1st University Medical Clinic, where **Karl Friedrich Wenckebach** (1864–1940) worked and researched. He made his name through his work on cardiac arrhythmia, and his book *Die unregelmäßige Herztätigkeit* (Irregular Heart Activity) became a standard text in cardiology. The Wenckebach-period, a typical heartbeat irregularity, is a term still familiar to doctors today.

path in psychiatry was not leading to any real results, Meynert's research into brain anatomy made psychiatry socially acceptable – or to be exact, acceptable to the universities. His discoveries concerning the architecture of the cerebral cortex and the neural network are still valid today. His conflict with **Sigmund Freud** (1856 –1939), who also worked in his laboratory, has entered medical history. In addition to professional differences – Meynert rejected hypnosis as a therapeutic method – personal motives could also have played a role in this quarrel.

In contrast to Meynert, who tried to explain psychological phenomena from

Turning to the left, we discover the memorial to a once world-renowned medical pioneer of ear, nose and throat medicine: **Ludwig Türck** (1810–1868). His scientific publications were often just a few days too late, and therefore others achieved the fame that might have been his. But in the dispute over the invention of the laryngoscope that first enabled direct observation of the human larynx, Türck took decisive action. His heated quarrel with the physiologist **Johann Nepomuk Czermak** (1828–1873) entered medical history as the *Türkisch War* (a word-play on the many wars against the Turks in Austrian history). However this quarrel was highly beneficial for the development of the new medical science of laryngology, and within a short time this new area flourished.

With the invention of the laryngoscope, Türck had laid the foundation for the new specialised subject of laryngology. In 1870 the University established the world's first clinic exclusively for the study and development of larynology, and the first head of the department was a former student of Skoda and Türck, **Leopold von Schrötter-Kristelli** (1837–1908). Schrötter developed dilatation treatment to relieve constriction of the larynx and so saved many patients from the need to undergo a tracheostomy. Schötter's pewter pins and hard rubber tubes were known to every laryngologist. He achieved such renown that in 1886 he was among a group of specialists called upon to treat the German Emperor Friedrich III, who suffered from cancer of the larynx.

A few steps further we find the two architecturally and art historically interesting buildings of the old **female clinics**. The opening ceremony on October 21st 1908 was combined with the unveiling of the memorial to **Ignaz Philipp Semmelweis** (1818–1865) that stands in the garden between the two buildings.

Semmelweis gained world renown as the "saviour of mothers". He discovered the importance of hygienic hand disinfection, but, in a strange twist of fate, died of the very disease from which he protected mothers who had given birth. Semmelweis began his training in the obstetrics department of Vienna's old General Hospital in 1844. At that time in the "General" the ward was separated into two clinics: one, the midwives clinic where midwives

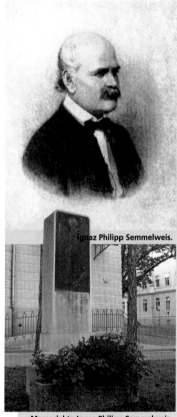

Ignaz Philipp Semmelweis.

Memorial to Ignaz Philipp Semmelweis.

were trained, and the other, the doctors clinic, where medical students also trained. Both were close to each other, in the 8th and 9th courtyards, but Semmelweis noticed that among women due to give birth the death rate due to **puerperal fever** (a much-dreaded complication during child birth) was much lower in the midwives' clinic than the doctors' clinic.

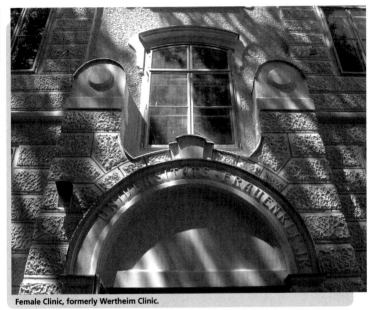

Female Clinic, formerly Wertheim Clinic.

The usual hypotheses about the cause of puerperal fever – cosmic telluric forces, miasmata or weather factors failed to convince Semmelweis. He saw that the two clinics were directly beside each other, that the patients received the same treatment, ate the same meals and used the same bed linen. Two things struck him: firstly in the midwife clinic the women became ill only sporadically, whereas in his own department dozens of patients fell ill, and secondly that women who gave birth a longer time after the expected date fell ill more often then those who gave birth shortly after entering the hospital. Being a true student of Rokitansky and Skoda, he tried to find the pathological-anatomical cause of this mysterious mass mortality by conducting daily autopsies. The changes in the bodies were always the same – lymphangiotis, phlebitis, pyaemia and metastasis.

Then chance came to his aid: his friend, the forensic pathologist **Jacob Kolletschka** (1803–1847), died after a clumsy student had injured him with a scalpel "infected by a cadaver". The results of his dead friend's autopsy put Semmelweis on the right track; Kolletschka died from pyaemia with lymphangiotis, phlebitis and pleurisy. Pyaemic metastases were found in his eyes. Suddenly everything became clear to Semmelweis: puerperal fever and Kolletschka's illness – what was called "corpse infection" – were one and the same.

Die Aetiologie, der Begriff

und

die Prophylaxis

des

Kindbettfiebers.

Von

Ignaz Philipp Semmelweis,

Dr. der Medicin und Chirurgie, Magister der Geburtshilfe, e. ö. Professor der theoretischen
und practischen Geburtshilfe an der kön. ung. Universität zu Pest
etc. etc.

Pest, Wien und Leipzig.
C. A. Hartleben's Verlags-Expedition.
1861.

**Kindbettfieber (puerperal fever),
appeared in 1861.**

"And so, I reasoned further, if Professor Kolletschka's pyaemia was the result of contamination by parts of a corpse, then puerperal fever must also stem from a similar source. But I needed to discover how parts of decaying corpses could have infected the mothers-to-be".

In a short time Semmelweis was able to answer the riddle. The fingers of the doctors and students, who examined the pregnant women directly after dissection practise, were what spread death.

"If this reasoning were true, then the elimination of the cause would also eliminate the mass mortality. In order to destroy the elements from the corpses still present on the hand, it was ordered that hands should be washed with chlorine".

The success was startling. After the introduction of washing with chlorine the mortality rate, which until then had been 18 per cent, dropped within the next few months to 2.45 per cent. Now it also became clear why the midwife clinic remained relatively free of disease – the students there had nothing to do with post-mortem examinations and the doctors there, too, seldom used the dissecting room. As the methods Semmelweis used to reach his conclusions were an almost classic practical example of the teachings of Rokitansky and Skoda, it came as no surprise that the most prominent representatives of the Second Viennese Medical School Rokitansky, Skoda and Hebra immediately gave their full support to Semmelweis' new discovery.

There followed a whole string of discussions – some bordering on the absurd – with many of his colleagues and superiors strongly resisting the new doctrine. The most likely reason for this resistance was given by Semmelweis himself in his major work "The Causes, Understanding and Prevention of Childbed Fever", where he wrote: "Consistent with my convictions, I must profess that only God knows the number of those who, because of my actions, went to an early grave"

Instead of using scientific arguments Semmelweis went on to defend his findings against his critics with passionate and fanatical attacks. Despite the ongoing conflicts, he qualified for a professorship in Vienna and had a promising scientific career before him;

but in 1851 he suddenly left to take up an unpaid post as senior physician in an obstetrics department in Budapest. In 1855 he became professor of obstetrics at Budapest University. However his theories were still a long way from being recognised and accepted, and the battle against his opponents became increasingly heated. Nothing could cause him to lose his composure more than his colleagues' lack of understanding. It was at this time that the first symptoms of mental illness began to appear, and reached their pinnacle in the "midwife-oath scene". At a professors' committee meeting, Semmelweis was expected to suggest someone for the post of assistant, but instead he took out of his suit pocket the midwives' oath, which, to everyone's great surprise, he read from beginning to end. After a consultation between his colleagues, on 31

Friedrich Schauta.

July 1865 Semmelweis was taken first to the house of his friend Hebra in Vienna, then soon after to the mental asylum in Lazarettgasse. On the admission form, found after being misplaced for over a hundred years, it is noted that apart from his confusion, he had a gangrenous wound on his finger (the cause of which was unknown), fever, and a pulse rate of 120. According to the autopsy report, Ignaz Semmelweis died on August 13 of pyaemia. This was the same illness, today known as septicaemia, that had caused the tragic death of his friend Jacob Kolletschka and which had led to Semmelweiss to discover the cause of puerperal fever.

When built in 1908 the obstetric clinics on each side of the memorial were the largest and most modern in the world. The head professors of the gynaecological departments, **Friedrich Schauta** (1849–1919) and **Rudolf Chrobak**

Rudolf Chrobak in the lecture hall.

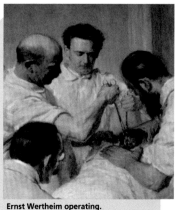

Ernst Wertheim operating.

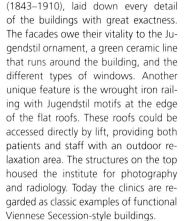

Fig. 527/929

Instruments for the Wertheim operation.

Drawing of an operation specimen.

(1843–1910), laid down every detail of the buildings with great exactness. The facades owe their vitality to the Jugendstil ornament, a green ceramic line that runs around the building, and the different types of windows. Another unique feature is the wrought iron railing with Jugendstil motifs at the edge of the flat roofs. These roofs could be accessed directly by lift, providing both patients and staff with an outdoor relaxation area. The structures on the top housed the institute for photography and radiology. Today the clinics are regarded as classic examples of functional Viennese Secession-style buildings.

The world-famous gynaecologists Friedrich Schauta and **Ernst Wertheim** (1864–1920) both worked and researched here in the obstetrics and gynaecology clinic. For years Schauta und Wertheim conducted a bitter scientific debate about the best surgical method of dealing with cervical cancer. Before the turn of the century they had adopted different methods of operating: Schauta favoured removal of the cervix and any suspect tissue through the vagina, whereas Wertheim preferred a radical abdominal operation where, after opening the abdominal wall, the cervix, lymph nodes and parametric connecting tissue were removed. Both methods involved great risks. Due to the size and duration of Wertheim's radical operation, up to 74 per cent of the patients died. The vaginal operation caused considerably fewer deaths – "only" 32 per ent of patients died shortly after intervention, but difficult access meant that the operation was seldom radical

enough and very few women could be cured of their cancer. Both gynaecologists managed to improve their success rates over time, but no decisive advance was possible until the introduction of radium treatment in 1913.

Before leaving the grounds we should take a look at the administration building and the adjoining **chapel**. This most impressive building known as the *Materialkanzlei* (**materials chancellery**) has a columnar entrance hall with mighty stone columns and a rib-vaulted ceiling as well as a glass-roofed courtyard on the first floor. The entrance hall also leads to the adjoining chapel.

We leave the grounds of the "New Clinics" through the gateway at 23 Spitalgasse. If we look to the right here, on the opposite corner of Spitalgasse/ Sensengasse we see the architecturally somewhat mistreated building that is home to the Viennese institute of forensic medicine.

Under the direction of **Eduard von Hofmann** (1837–1897), who came to work here in 1875, the Viennese forensic medicine institute developed into one of the best and most famous in the world. The collection of interesting exhibits that he started can today be found in the wonderful old lecture theatre of the k. und k. Garnisonspital (Royal and Imperial Garnison Hospital). It is one of the most comprehensive and interesting forensic collections in the world, and, with more than 2000 exhibits, offers a unique "living" textbook of forensic medicine.

Diagonally behind it to the right, almost at right angles to the forensic medicine building, is the former pathological-anatomical institute, where the man who was probably the best descriptive pathologist of all time, **Carl von Rokitansky** (1804–1878) worked, and where in 1900, **Karl Landsteiner** (1868–1943) discovered the blood group ABO.

Strolling down Spitalgasse, we can see in the distance the characteristic tower of the Spittelau waste incineration plant designed by Friedensreich Hundertwasser. The district heating plant was built in 1971 to supply the heating for the General Hospital about 2 kilometres (1-1/4 miles) away. After a fire had damaged the building, the famous painter Hundertwasser was persuaded in 1989 to design a new facade, transforming the austerely functional building into a spectacular work of art that has subsequently become a well-known tourist attraction.

After a walk of about 200 metres we come to Arne Karlsson Park on the corner of Währinger Strasse. Here we find the life-size bust of a radiologist who entered the medical history books as a martyr to his profession: **Guido Holzknecht**. This bronze bust by Josef Heu was unveiled just one year after his death on 6 November 1932. The trans-lation of the inscription below the bust is: Guido Holzknecht 1872–1931, Professor of Radiology, Pioneer and Martyr to Science.

🏛 Café Wien Clinicum

1090 Vienna, Währinger Gürtel 18-20 (Allgemeines Krankenhaus/General Hospital)
Tel.: 408 99 52
Monday to Friday 7am to 8pm, Saturday, Sunday and holidays 11am to 6pm

Tour 6

The White City
and Lemoniberg

Starting point:
*Steinhof fire station. Underground line U3 to Ottakring,
then with the bus 46 B or 146 B to Steinhof fire station.
The Steinhof grounds are open from 6.30am until dusk.
Alternative route: bus 48A from Dr. Karl Renner Ring direct to
the main entrance to the medical centre Baumgartner Höhe/Otto Wagner Hospital.*

End:
*Entrance to the Pulmonary Centre
or the Otto Wagner Hospital, bus 48A.*

Duration:
3 hours

Store

Nursery garden

Boiler house
Kindergarten
P buildings

Pharmacy
Vehicle fleet
T buildings

Pathology
Sports field

Occupational therapy building

D buildings

Church

W

24 20 35

18 12 14 8

Kitchens

16 10 6 4

V Theatre

2 A B

21 19 13 7 Administration A1

17 15 9 1 B1

Annenheim 3 5 B1

Marienhaus

Severin ...buildung Wienerwald

Karlshaus ...bohona... Administration

Leopold Spa building

Austria – Felix

*Tour of the church every Saturday at 3 pm.
Viewing without tour, Saturday from 4 pm.
Tours can also be given after 3 pm from
Monday to Friday. Please make an appoint-
ment by phoning 0664 103 10 50.
Exhibition: The war against the "inferior"
in Pavilion V.
Opening hours:
Wednesday and Thursday: 10 am – 4 pm
Friday 3 pm – 8 pm*

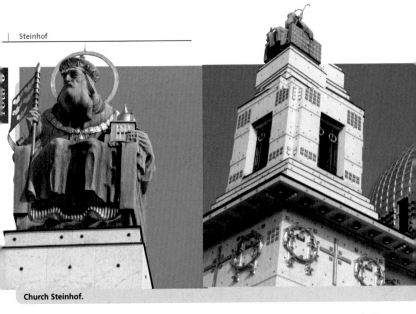

Church Steinhof.

This tour leads us not only through what was once the largest and most modern psychiatric facility in Europe but also through one of Vienna's unspoilt natural recreation areas. We start our short walk at the **Steinhof** fire station and follow the signpost to join the so-called "Rundumadum" trail, which leads in 24 stages through the green belt encircling Vienna. Through a gate next to the fire station we enter **Steinhof Park**, once part of the grounds of Steinhof psychi-

Steinhof Park.

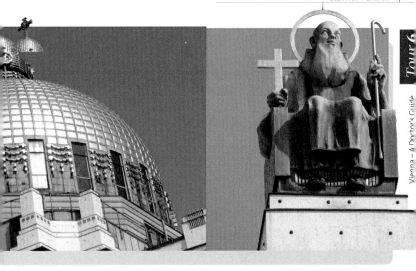

atric hospital (known today as the **Otto Wagner Hospital**) and formerly used for agricultural purposes. At the beginning of the 20th century psychiatric theory called for a "healthy and healing" location far outside the town, which resulted in the creation of this almost self-sufficient small community. Steinhof, or the "white city" consisted of 60 **pavilions**, administrative buildings, an agricultural section, a theatre, and the symbol of the institution, the golden-domed **church** towering over the entire area and visible from miles away. After passing a spring with a wooden trough that soon appears on the right of the broad path, we must keep our eyes peeled. We continue along the path, and try to find the church's golden dome through the woods on the left – not so easy during the time of year when it is hidden by foliage. After discovering the golden dome (or as it is affectionately known, **Lemoniberg**, due

to its similarity to half of a lemon) from now on it becomes our target. We follow the next path that leads to the left, also to the south, to try and gain entry into the huge institute from above. Now a little scouting ability is called for, but if one continues to walk south, that is roughly at right angles to the main path, the church is hard to miss. A wire fence shows us that we are on the right track. By passing either through a gate or a hole in the fence we abruptly stand either behind or next to the "Church of Saint Leopold", Steinhof church, the world-famous "jewel of Jugendstil".

"Am Steinhof", the "Niederösterreichische Landes- Heil- und Pflegeanstalt" (Lower Austrian treatment and care centre), later the Psychiatric Hospital of the City of Vienna–Baumgartner Höhe, and today known as the Otto Wagner Hospital, was, when it was opened in 1907, Europe's largest and most modern mental hospital. Experts from all

Memorial in front of the Jugendstil Theatre.

over the world came to Vienna to visit and study this institution. In 1902 the Lower Austrian Assembly decided to sell the Brünnlfeld Provinical Lunatic Asylum, which was in the 9th district, approximately where the new clinical complexes of the General Hospital (AKH) now stand, and to build a new complex based on the pavilion system on the south-facing slope of Gallitzinberg. The areas of "Spiegelgründe" and "Steinhofgründe" between the 13th and 16th districts were selected as the site for the new development, and Vienna's leading contemporary architect **Otto Wagner** (1841 – 1918) was commissioned to design the scheme. Although Wagner took over an existing plan of the Regional Building Authority, he gave the extensive complex a far stricter symmetrical balance. Today, the severe axiality of his designs has been blurred or hidden by tree growth, and

in fact can now only be fully appreciated from the air. The planned 34 pavilions, **head offices**, theatre and church on each side of the main axis, and to the northeast, outbuildings, pigsties, horticultural gardens and even a refuse incineration plant, were intended to ensure that the complex, enclosed within five kilometres of perimeter wall, would become a small self-sufficient town. Construction started on 27 September 1904, and within only three years, without the use of cranes and trucks, the topping out ceremony could be held in the church in the presence of heir to the throne, **Archduke Franz Ferdinand**, on 8 October 1907. The institute was planned to accommodate 2500 to 2700 patients, and, to reduce the risk of "the inmates automatically multiplying", "Steinhof" was divided into male and female tracts on either side of its central axis. Standing on the highest point

Pavilion of the psychiatric complex.

of the site and crowning the entire development is Wagner's Steinhof church, which is regarded as the major religious building of Austrian Jugendstil. Here Wagner built a pioneering new form of church architecture that was, of course, also intensely criticised. The construction of the dome was planned with utmost functionality and fabricated down to the last detail in the purest Jugendstil. Because the dazzling "golden dome", could be seen from miles around the Viennese christened the institute "Lemoniberg" (literally Lemon Mountain). The terms "Steinhof", "Lemoniberg" and "Gugelhupf" the latter referring to the cylindrical shape of the "fools' tower" in the old general hospital were and still are used in Vienna as terms synonymous with psychiatric institutions.

The façade of the church is clad with white Carrara marble panel that are fixed to the brick walls with exposed

Main administration building.

copper bolts. The magnificent effect made by the interior is due in part to the stained glass windows by **Koloman Moser** (1868 – 1918). The tabernacle, altar, holy water dispenser, lighting, confessionals and even the liturgical utensils and vestments were made to designs by Otto Wagner. The smallest details were designed not only from the aesthetic viewpoint but also taking into account the special needs of the mentally ill. Three entrances allowed the nursing staff and the female and male patients to enter separately. The short rows of pews made it possible for the male nurses to intervene quickly in the event of an emergency. The pews themselves were made without sharp corners and the lower parts were clad with copper to allow the floors to be washed thoroughly without damaging the wood of the pews. The holy water fonts drip water to reduce the risk of infections and to prevent people "splashing with water". There were also a doctor's room, a first-aid room and toilets. The gallery, which can only be reached from an outside entrance, allowed relatives and hospital staff to attend the services. Today both art historians and art lovers come from all over the world to the psychiatric hospital now officially named the Otto Wagner Hospital, but still known to the Viennese as Steinhof, to admire and study the finest example of Jugendstil religious architecture.

We now walk down past the pavilions, (which, although it is not obvious, have escape-proof windows, the bars are skilfully hidden by the window mullions), soon arriving at the restored and reopened Jugendstil theatre on the left. The permanent exhibition entitled "The War Against those Deemed Inferior" in pavilion V is a memorial to a dark and depressing chapter not only in the history of the treatment and care institution "Am Steinhof", but of the medical profession as a whole. After the annexation of Austria in 1938, Steinhof developed into the National Socialist centre for "Rassenhygiene" ("cleansing of the national body") in what was called the "Ostmark". This "racial cleansing" of patients cost the lives of 7500 people who were in the care of the hospital. This figure included not only "foreigners", such as Jews, Slavs, Roma and Sinti, but also members of their own

"race" who carried genetically "inferior" material such as the physically disabled, the mentally ill, those from socially marginalised groups or those who simply refused to conform. An impressive memorial with a bed of hundreds of roses and lights standing in front of the Jugendstil theatre recalls these hideous crimes.

At the Jugendstil theatre we turn right and saunter past the beautifully restored pavilions – in 1979 one of Freud's most celebrated patients died here, the Russian aristocrat **Sergius Pankejeff**, who entered the annals of psychotherapy under the name of the Wolf-man – to the one time sanatorium for wealthy "guests". Here, at some distance from the main complex, was the luxurious sanatorium for paying patients. One notices immediately that one has arrived in the sanatorium area. Here the buildings are no longer called pavilions but **villas**, and the windows have no bars. Winter gardens with palms, skittle-alleys, a swimming pool, a skating rink and tennis court were available for the distinguished, and above all affluent, emotionally ill patients, in what

was at the time Europe's most beautiful and elegant sanatorium. A 1903 building programme notes that "Several of the pavilions are connected by covered walkways in consideration of well-off people's greater sensitivity to wind and weather". One of the most prominent patients in the sanatorium was the famous dancer **Vaslav Nijinsky**. After the First World War, however, wealthy patients no longer came here. In 1923 the anatomist and city health councillor **Julius Tandler** (1869 – 1936) converted the elegant pavilions into a sanatorium for the treatment of consumption, and after the 2nd World War, the institution, with almost 1000 beds, was Central Europe's largest tuberculosis sanatorium. Since 1977 the "Pulmological Centre" has been accommodated in this part of the complex.

After strolling back to the exit to the Otto Wagner Hospital, we can take the 48A bus back to the Underground station (U3 Ottakring) or we can stay on the bus and travel into town, arriving at Dr. Karl Renner Ring, directly beside the parliament building, which is the last stop.

⫴ Großes Schutzhaus Rosental

1140 Vienna, Heschweg 320
Tel.: 911 47 51
Monday to Wednesday and
Friday to Sunday 10am to 11pm

Billroth House, Society of Physicians
9th District, 8 Frankgasse

Tour 7

Tour 7

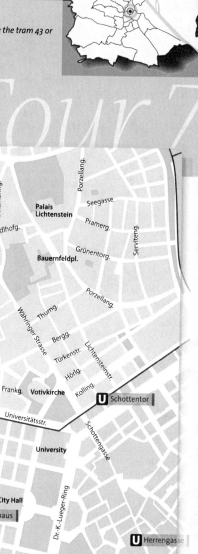

W. Exner G.

Bolzmanng.

Porzellang.

Seegasse

Palais Lichtenstein

Pramerg.

Strudlhofg.

Serviteng.

Tendlerg.

Grünentorg.

Bauernfeldpl.

General Hospital

Spitalgasse

Senseng.

Porzellang.

Thurng.

Wähinger Strasse

Old General Hospital

Gamisong.

Bergg.

Lichtensteinstr.

Türkenstr.

Lazarettg.

Hörlg.

Kolling.

Marianneng.

Frankg.

Votivkirche

U Schottentor

Universitätsstr.

Schottengasse

Laudong.

Landesgerichtsstr.

University

Florianig.

Lange Gasse

City Hall

Dr.-K.-Lueger-Ring

U Rathaus

Josefstädter Str.

U Herrengasse

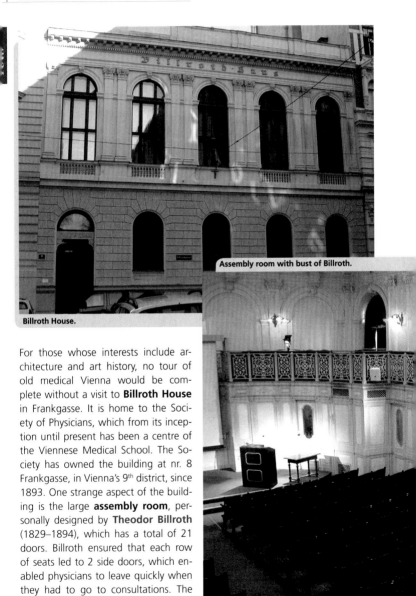

Assembly room with bust of Billroth.

Billroth House.

For those whose interests include architecture and art history, no tour of old medical Vienna would be complete without a visit to **Billroth House** in Frankgasse. It is home to the Society of Physicians, which from its inception until present has been a centre of the Viennese Medical School. The Society has owned the building at nr. 8 Frankgasse, in Vienna's 9th district, since 1893. One strange aspect of the building is the large **assembly room**, personally designed by **Theodor Billroth** (1829–1894), which has a total of 21 doors. Billroth ensured that each row of seats led to 2 side doors, which enabled physicians to leave quickly when they had to go to consultations. The 300-seat chamber and gallery displays

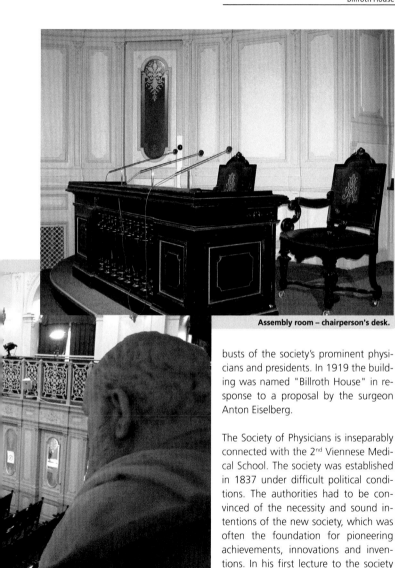

Assembly room – chairperson's desk.

busts of the society's prominent physicians and presidents. In 1919 the building was named "Billroth House" in response to a proposal by the surgeon Anton Eiselberg.

The Society of Physicians is inseparably connected with the 2nd Viennese Medical School. The society was established in 1837 under difficult political conditions. The authorities had to be convinced of the necessity and sound intentions of the new society, which was often the foundation for pioneering achievements, innovations and inventions. In his first lecture to the society given on Nov 30th 1839, Joseph Skoda explained the physical fundamentals of auscultation and acouophonia /percus-

Staircase.

Silence.

sion, emphasising its diagnostic significance in clinical examinations. In December 1847, Ferdinand Hebra, who is today recognized as the founder of modern dermatology, gave a lecture on the discovery by his friend Ignaz Semmelweis of the causes of puerperal fever. It was only three years later, on 15 May 1850, that the reserved and publicity-shy Semmelweis could finally be persuaded to give a lecture on puerperal fever to the society.

Under the presidency of the pathologist **Carl von Rokitansky** from 1850 until his death in 1878 the society gained increased political respect. Questions of public hygiene became increasingly important and the society was regularly asked by the government to present reports on such matters. It became, so to speak, the conscience of hygiene in

Vienna. In 1862 the Viennese local authority planned to filter Danube water for drinking purposes, but a committee of the society was of the opinion that spring water should be supplied. A memorandum entitled " Vienna's water supply as seen from the physicians' viewpoint", began with the following sentence: "As is shown by the figures concerning cases of illness and mortality it is an irrefutable and conclusive fact (which should be seen as a first warning – that cannot be too often repeated – to undertake long-neglected remedial measures), that Vienna has the dubious privilege of being the unhealthiest city on the European continent. "

The report, written against the background of the London cholera epidemics of 1849 and 1854, was eventually successful. The water for the

Registry.

Reading room.

first Viennese water supply which was built in 1873 came from sources in the Rax and Schneeberg mountain regions. The correctness of the measures taken became almost immediately apparent – whereas the number of fatalities caused by typhoid fever in Vienna in 1871 was 1149, a few years later this figure had sunk to 185. Apart from increasing knowledge in specialized areas, it was the development of new medical instruments that brought world renown to Viennese medicine. Almost all of these newly developed instruments such as the laryngoscope, the cystoscope for examining the bladder, the esophagoscope, and the gastroscope were first presented to the Society of Physicians. Billroth gave his first lecture to the society a year after being appointed to the chair of surgery at Vienna University, and dominated this

sector until his death in 1894. Many of the operations he performed in Vienna were revolutionary and he became world famous for successfully carrying out the very first gastrectomy on a patient with stomach cancer on 29 January 1881. In a meeting four weeks later, Billroth gave his report of the operation entitled: "constriction of the digestive tract by carcinoma" to the Society, stating that "at the moment the lady is very well, and has returned to her family home" A few months later however, the woman died after a relapse. Billroth had already pointed out in his lecture that he had been able to feel small cancerous lumps in other areas of the apparently only inflamed stomach. Today the preserved specimen of Billroth's first pylorus resection can be seen in the Medical History Museum in the Josephinum.

In 1884 **Karl Koller** presented his discovery of using a solution of cocaine as a local anaesthetic on the eyes, an idea that had originated from Sigmund Freud. In the meeting on 17 October 1884, it was pointed out that the experiment with cocaine had been carried out on Freud's suggestion and consequently there was no dispute about who had been first. In 1886 Freud himself attracted considerable attention with his lecture "On Male Hysteria" which was rejected by all sides.

In 1888, Billroth, as the elected president of the Society, started to campaign strongly for the erection of the Society's own premises, as the lack of space in the old University was making work there increasingly difficult. Lectures had to be held leaving the doors to the corridors open, where many physicians would stand to follow the lectures. With great personal commitment – Billroth donated the considerable sum of 5000 guldens of his own money – they finally succeeded in erecting the building in Frankgasse, which he personally inaugurated on 27 October 1893.

Archive.

Shortage of space prohibits even a much abbreviated list of all the significant lectures held here. It goes without saying that the 3 Viennese Nobel prizewinners **Robert Barany, Julius Wagner-Jauregg** and **Karl Landsteiner** all spoke about their work to the Society of Physicians. The core of Billroth House and treasure of the Society of Physicians is the library, with its 25,000 monographs and 2000 historically invaluable journals, for which the institu-

tion has gained worldwide recognition. There are few libraries that have such a complete series of periodicals spanning a hundred years and more. Today the extensive **archive** – which includes Billroth's complete official and private correspondence – has been moved to the Institute for the History of Medicine in the Josephinum due to lack of space. For friends of old libraries, the **reading room** is a pleasure that is hard to resist, a room where the hours can slip by while browsing.

Reading room.

Society of Physicians in Vienna

9ᵗʰ District, Frankgasse 8

Telefon: +43 1 4054777
Fax: +43 1 4023090
Mail: info@billrothhaus.at
Homepage: www4.billrothhaus.at

Opening hours:
Library:
Monday to Friday: 2pm– 6pm,
Saturday by prior arrangement
Office/literature service:
Monday to Friday: 9am – 6pm

☕ Caféteria Maximilian

1090 Vienna, Universitätsstrasse 2
Tel.: 405 71 49
Monday to Friday 8am to 12 midnight,
Saturday 9am to 12 midnight,
Sunday 11am to 11pm

Tour 8

Der Wiener Zentralfriedhof /
Vienna Central Cemetery
11th District, 234 Simmeringer Hauptstrasse
Open throughout the year

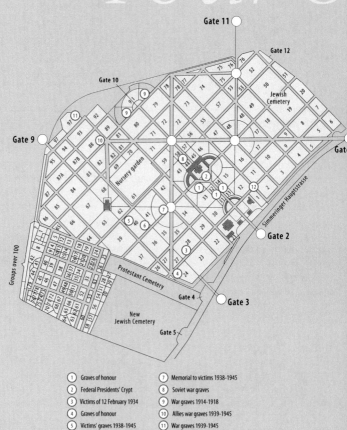

Starting point:
Zentralfriehof Haupttor (Tor 2) / Main Entrance, Gate 2;
take tram line 71 from Schwarzenbergplatz

End:
Haupttor (Main Entrance)

Duration:
3 hours

Tour 8

Gate 11

Gate 12

Gate 10

Jewish
Cemetery

Gate 9

Gate

Nursery garden

Gate 2

Simmeringer Hauptstrasse

Gate 3

Groups over 100

Protestant Cemetery

Gate 4

Gate 3

New
Jewish Cemetery

Gate 5

1. Graves of honour
2. Federal Presidents' Crypt
3. Victims of 12 February 1934
4. Graves of honour
5. Victims' graves 1938-1945
6. Graves of honour
7. Memorial to victims 1938-1945
8. Soviet war graves
9. War graves 1914-1918
10. Allies war graves 1939-1945
11. War graves 1939-1945
12. Old anatomy graves

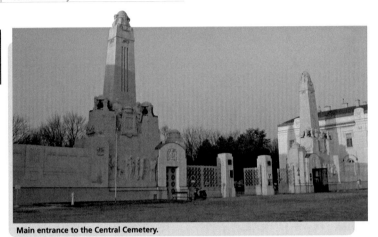

Main entrance to the Central Cemetery.

It is not just the graves of honour that, for many visitors to Vienna, make the Central Cemetery a "must" on their list of sights to be seen. And this huge city of the dead is naturally of medical historical interest not only because of the numerous graves of honour of eminent figures from the world of medicine. Despite, and occasionally also because of the art of medicine, all life leads ultimately to death. This truism, however, touches upon a central problem of every human community and in particular of every large city: the hygienic removal of corpses in a way that does not endanger the living. Naturally at no time and in no culture has the burial of the dead been looked at solely from the point of view of hygiene. And certainly not in Vienna where it has long been said that the inhabitants have an intimate relationship to death. The Viennese are willing to fork out for a "schöne Leich" (beautiful corpse) and thus many a person has been "buried more extravagantly than he ever lived".

Although burials in the cemeteries within the city area of Vienna were already prohibited in 1732 on account of pestilence and the danger of polluting the ground water, and under Emperor Joseph II in 1784 all crypts, churchyards and so-called "God's acres" in the city were closed down and "communal" cemeteries were established far outside the settled area, by the mid-19th century it was foreseeable that the existing cemeteries would soon no longer be able to accommodate all the dead of the big city. In 1863 the Vienna Municipal Council therefore decided to abolish the church's monopoly of burial places and to erect a large new, interdenominational central cemetery at the cost of the council. A large flat site with sandy soil in Kaiserebersdorf, in an area where the dominant wind blew away from the city, was acquired and the Frankfurt architects **Mylius** and **Bluntschi** were commissioned with the project. It was above all the interdenominational nature of the project that made the new

Sign.

One problem with the new cemetery was its considerable distance from the city. Horse-drawn carriages were the only means of transport and in poor weather, especially during snow, chaos regularly broke out. The horse carriages remained stuck in the snow or mud and occasionally the coffins had to be left in the taverns that lined the route. Up to 10,000 corpses had to be transported to the cemetery each month along Simmeringer Hauptstrasse. There was no shortage of strange solutions to this problem suggested. In 1874 the project for a "pneumatic corpse transport" was discussed by the council. After being blessed the corpses were to be lowered into a machine room in the city centre and transported to the Central Cemetery by means of air pressure. The council rejected the project by the two inventors **Franz von Felbinger** and **Josef Hudetz** on moral grounds. A proposed railway line especially for the transport of corpses, with a central collecting point in a former wholesale market was also rejected. It was decided to develop the existing horse-drawn tramline which, however, was not used for the transport of corpses. It was only after the First World War that the tramline, which had been electrified in 1901, transported coffins in special carriages to the Central Cemetery. The first motorised hearse in Vienna was introduced in 1925. Up until the end of the Second World War one could choose between a funeral with a horse-drawn coach or with a motorised hearse.

cemetery a cause of controversy before it even opened. The Catholic Volksverein (People's Association) was appalled by the fact that it was wished "to hastily bury us Catholics with thieves, murderers, suicides and people without any professed religion."

When it then became known that the Jewish community was to be allotted its own section an immense storm of protest arose and the Catholics vehemently demanded the immediate dedication of the site. As, even a few days before the planned opening, the council still could not reach a clear decision Cardinal **Rauscher** took action with the acquiescence of Mayor **Kajetan Felder**. On 31 October 1874, a day before the official opening, he quietly carried out the dedication of the cemetery in the early hours of the morning. Thus the cemetery, which had been intended to be open to all denominations became a Catholic graveyard with Protestant, Jewish, Russian Orthodox, Greek Orthodox and Islamic sections. The official opening on 1 November 1874 took place almost unnoticed.

However a number of years were to pass before the Central Cemetery de-

Lueger Memorial Church.

veloped into what it is today, namely an attraction that features on many tourists' sightseeing list. It was under the mayor **Karl Lueger** that the cemetery was more given a more imposing appearance. In 1898 architect **Max Hegele**, who was only twenty-seven years old at the time, won the competition for the design of the main entrance, the halls of rest and the church. The construction work was concluded in 1911 with the completion and dedication of the church. Lueger, who had died a year previously, was buried in the crypt of the church that was named after him: **Dr Karl Lueger Gedächtniskirche** (Dr Karl Lueger Memorial Church). The mighty church building with its huge dome and richly decorated interior is one of Vienna's most important Jugendstil build-

ings and many Austrian artists were involved in this *gesamtkunstwerk*. The stained glass windows came from the workshop of Kolo Moser.

In addition to the church the graves of honour donated by the council are the main attraction of the cemetery. Eminent Austrians from the worlds of the arts, politics and science over the last two hundred years lie buried there. To make the cemetery more attractive to the Viennese population in 1884 the council ordered that the remains of several important figures worthy of commemoration should be disinterred from the old cemeteries of Vienna and reburied in the Central Cemetery, thus laying the foundation stone for this Austrian Pantheon.

Those who have more time at their disposal should pay a visit to the **crematorium** opposite the central cemetery. The crematorium was erected to plans by **Clemens Holzmeister** (1886–1983) in the grounds of the **"Neugebäude"** – a former imperial palace in Simmering dating from the 16th century. It is today regarded as Austria's most important "Expressionist" building. Holzmeister was granted the commission as in its basic approach his design related to the Neugebäude palace nearby. This building was Holzmeister's breakthrough as an architect and the crematorium became the basis for a successful career in Austria that extended over several decades.

Crematorium.

Former pump room of Neugebäude Palace, now the crematorium administration.

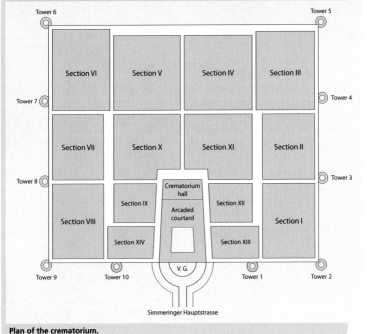

Plan of the crematorium.

It was primarily religious objections that for a long time hindered the general recognition of cremation. In 1892 the church still forbade the cremation of corpses, under pain of excommunication, and refused the sacraments to dying persons who intended to have themselves cremated. Despite this crematoria grew up in Europe and North America from around 1873 onwards. The first Austrian crematorium here in Simmering was opened on 17 December 1922. It was only in 1963 that the Roman Catholic church altered canon law, in 1966 the Archdiocese of Vienna accorded cremation the same recognition as burial in the ground.

In the 19th century, doctors, scientists, philosophers and also a number of enlightened citizens began to support the introduction of cremation. Hygienic, aesthetic and also practical economic considerations played a role here. Cities were growing as a result of increasing industrialisation and land prices rose rapidly. At international congresses the option of cremation was demanded for hygienic reasons. But inventors had yet to develop cremation furnaces that allowed the burning of corpses without offensive fumes or smoke. In 1873 the Italian pathologist **Ludovico Brunetti** presented his "corpse burning apparatus" at the World Fair in Vienna. In Germany the **Friedrich Siemens** Company constructed a burning furnace with a "patented regenerative gas-fired system" that was widely acclaimed, functioned perfectly and that spread throughout Europe. The first crematoria were opened in England in1873, in

Milan and Washington in 1876 and in Germany in 1878 in Gotha. For a long time this first German crematorium had a reputation in intellectual circles. **Berta von Suttner**, winner of the Nobel Peace Prize who died in Vienna in 1914, was cremated in Gotha, because at that time cremation was not possible in Austria.

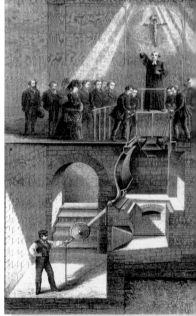

Crematorium furnace by Siemens.

Graves of medical-historical interest in the Vienna Central Cemetery, a selection:

Graves of Honour group 0

From the main entrance (Tor 2) go left. The graves are located along the cemetery wall. The old graves of group 0, row 1 are the final resting place of many prominent people whose remains were transported to the Central Cemetery from a number of smaller district cemeteries that had been closed down.

Viszanik Michael (1792 – 1872), number 5: psychiatrist. Head of a clinic in the Allgemeines Krankenhaus. Reformed the methods of treating the mentally ill. In 1839 he had the chains that were used to restrain ranting mad persons removed from the Narrenturm (literally "Fools' Tower").

Mundy Jaromir (1822 – 1894), number 16: together with Count Wilcek and Eduard Lamezan founder and chief physician of the Viennese voluntary medical rescue services. Regarded as a pioneer of modern emergency services and the transport of sick and injured persons.

Ernst Wertheim

Wirer Franz (1771 – 1844), number 55: court physician. Founder of the Gesellschaft der Ärzte (Society of Physicians). Discovered the healing powers of the springs in Ischl where he set up the first saline baths in Austria. Ischl became world-famous overnight after Archduchess Sophie, who had had problems conceiving, gave birth to a successor to the throne, Franz Joseph, following a saline treatment in Bad Ischl.

Jaromir Mundy

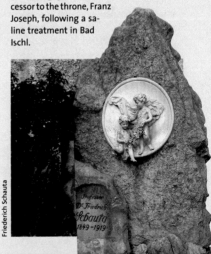

Friederich Schauta

Schauta Friederich (1849 – 1919), number 85: gynaecologist. Director of the I. Frauenklinik (1st Women's Clinic) in the AKH (General Hospital). Developed a method of operating that allowed a total extirpation of the uterus a through the vagina (even in the case of cervical cancer). With his operating method Schauta engaged in a scientific dispute with

Wertheim Ernst (1864 – 1920), number 87: gynaecologist. Professor at the II. Frauenklinik (2nd Women's Clinic) in the AKH (General Hospital). Developed the radical abdominal operation of the uterus (still used to today) that made it possible to treat cervical cancer successfully.

Graves of Honour group 12A

Main entrance (Tor 2). Proceed down the Hauptallee (main avenue) as far as the Alte Arkaden (old arcades), then turn right at the first cross-road. The old anatomy graves are located directly beside the old arcades.

Old anatomy graves: the final resting place of the remains of those enlightened men and women who in their wills left their bodies to the Anatomical Institute of the Medical Faculty for teaching purposes.

New anatomy graves: these were made available by the City of Vienna, as the old burial place had become too small. They are in group 26, R 1.

Graves of honour, group 14A:

Proceed about 300 metres along the Hauptallee (main avenue) from Tor 2 (Gate 2). The graves of honour are on the right-hand side.

Billroth Theodor (1829 – 1884), number 7: surgeon. Most important representative of the 2nd Viennese School of Medicine. Was the first in the world to carry out numerous types of operation: resection of the oesophagus 1872, first extirpation of a larynx 1873

Central Cemetery

DEM ANDENKEN JENER MANNER UND FRAUEN DIE NACH IHREM TODE DEM STUDIUM KUNFTIGER ARZTE UND DAMIT DEM ALLGEMEINEN WOHLE GEDIENT HABEN

Alte Anatomiegräber

and, finally, after ten years of preparation, in 1881 the operation that still bears his name: the first successful resection of the stomach.

Eduard v. Hofmann (1837 – 1897), number 6: founder of modern, scientific forensic medicine in Vienna. Hofmann became known through carrying out the autopsies on the 200 corpses of those who died in the Ringstrasse Theatre fire in 1881 and his post-mortem report on the death of Crown Prince Rudolf in Mayerling in 1889.

Ernst, Freiherr von Feuchtersleben (1806 – 1849), number 17: today he is known primarily as a poet, writer and economics politician. He reformed the Austrian school and university system at the time of the 1848 revolution – the motto being "freedom in teaching and learning". It is not so well known that the psychiatrist and poet-doctor Feuchtersleben is today regarded as a "pioneer of pyschosomatic medicine" and "predecessor of psychotherapy".

Schrötter Leopold, Ritter von Kristelli (1837 – 1908), number 19: Schrötter von Kristelli had a worldwide reputation as a laryngologist. He established laryngology as a special subject at the University of Vienna and also set up the first laryngology clinic in the world at the Allgemeines Krankenhaus in Vienna. Less well known perhaps are his achievements in the area of social medicine and his involvement in the battle against the most

...

serious and widespread epidemic in Vienna, tuberculosis, which was known as *Morbus viennensis*.

Weinlechner Josef (1829 – 1906), number 42: pioneer in the area of pediatric surgery. Alongside Billroth he was one of Vienna's most popular surgeons in the second half of the 19th century. He was known as a bold and gifted surgeon and was in demand in the highest circles. Even his imperial majesty Franz Joseph I had Weinlechner operate on him. His "elegance, absolute calm, remarkable care and astonishing precision" in operating were even praised in the "society pages" of the newspapers.

Graves of honour group 32A:

Proceed about 300 metres along the Hauptallee (main avenue) from Tor 2 (Gate 2). The graves of honour are on the left-hand side. Here there are many graves (much visited by tourists) of famous composers such as Beethoven, Brahms, Strauß, Schubert and the Mozart memorial. Mozart's remains, however, are still at the St. Marx cemetery.

Frank, Johann Peter (1745 – 1821), number 3: from 1795 to 1804 Director of the Allgemeines Krankenhaus (General Hospital). Excellent organiser and teacher. His lectures brought students from throughout Europe to Vienna. Today regarded as the founder of social medicine, forensic medicine and hygiene.

Graves of honour group 32C:

On the Hauptallee (main avenue) to the left, about one hundred metres from the graves of honour in group 32A.

Pirquet Clemens, Freiherr von Cesenatico (1874 – 1929), number 9: paediatrician. Inventor of the concept of allergies and founder of allergy research. In 1907 he described the tuberculin test, which made it possible to diagnose tuberculosis at an early stage without the use of x-rays. After the First World War he organised the American children's aid campaign in which up to 400,000 children were fed daily.

Wagner-Jauregg Julius, Ritter von (1857 – 1940), number 18: psychiatrist. In 1927 he received the Nobel Prize for Medicine for the discovery of the therapeutic significance of malaria inoculation in treating dementia paralytica, a mental illness that occurs in the later stages of syphilis and leads to death within a few years. Wagner Jauregg is the only psychiatrist to receive this scientific recognition. After the discovery of penicillin his malaria therapy was no longer needed. However, the addition of iodine to cooking salt to prevent goitre, which he suggested, is still practiced.

Schönbauer Leopold (1888 – 1963), number 26: surgeon. Director of the Allgemeines Krankenhaus. Towards the end of the war through his courage and prudence he protected the Allgemeines Krankenhaus (General Hospital) and his patients from suffering greater war damage. Together with Julius Tandler he set up the first cancer advice facility in Vienna.

Graves of honour, group 33 G:

To the east and behind the graves of group 32 C.

Ringel Erwin (1921 – 1994), number 2: suicide researcher and pyschosomatic doctor. He achieved international recognition through setting up the world's first suicide prevention centre in Vienna. Ringel succeeded in awakening interest in the themes of psychosomatic medicine and suicidology (which were little known at the time) – not just among specialists but also among the general public. After Freud, Adler and Frankl Ringel is regarded as one of the most important Austrian depth psychologists.

Graves of honour group 33 E:

To the left of the graves of group 33 G.

Posanner Gabriele, Freiin von Ehrental (1860 – 1940), number 22: The first woman medical doctor in Austria. Studied in Geneva and Zurich. It was only after a long struggle that she was able to open her practice in the 9th district.

Graves of honour group 37:

Pecha Albine (1877 – 1898): the last person to die from the plague in Vienna. She infected herself when looking after a laboratory worker who had in turn infected himself through carelessness in handling plague bacteria in the laboratory.

Müller Hermann Franz (1866 – 1898): like Albine Pecha he infected himself by treating the laboratory worker Franz Barisch for pneumonic plague. Both of them died in the Kaiser Franz-Josefspital in Vienna.

The Old Jewish Cemetery / Alte Israelitische Friedhof

Israelitische Abteilung, Tor 1 / Jewish Section, Gate 1:

Politzer Adam (1835 – 1920): founder of otology. Developed a method for examining the patency of the Eustachian tube. This technique is still known in otology as "politzerisation". Grave 8-1-45.

Stoerk Karl (1832 – 1899): Laryngologist. Was the first to undertake surgical intervention on the larynx, which he carried out without difficulty. This led to the abandonment of the medical dogma that had forbidden any kind of operational work on the larynx because of the fear of causing spasms of the glottis and death due to asphyxiation. Grave 8-62-43.

A simple grave in the Alter Israelitischer Friedhof (Old Jewish Cemetery) commemorates a patient on whom it was possible to carry out an eye operation painlessly thanks to the discovery of Karl Koller. Sigmund Freud's father, Jakob Freud, was one of the first to profit from the discovery of cocaine as a local anaesthetic. Approximately at the time of his son's cocaine episode he had to be undergo an eye operation. In the presence of Sigmund Freud Koller trickled drops of a cocaine solution into the eye and Königstein carried out the surgery without causing the patient any pain. Freud later wrote: "Koller make the remark that here all three persons were brought together who had been involved in the introduction of cocaine."

Grave of Jakob and Amalie Freud

Proceed along Zeremonieallee, which starts behind the large empty space that follows the entrance, to group 50/51. At the grave of the Gerngross family you turn to the left and after the fourth row of graves turn to the right. The simple grave with a wrought iron surround lies under an old maple tree. Grave 50-4-53.

Viktor E. Frankl

Freud Eltern

Guido Holzknecht

Frankl E. Viktor (1905 – 1997): He was Professor of Neurology and Psychiatry at Vienna University and for 25 years was head of the Vienna Neurologische Poliklinik. Logotherapy/ existential analysis, which he set up, is also termed the "Third Viennese Direction in Psychotherapy". He taught at Harvard University, as well as at the universities of Stanford, Dallas and Pittsburgh and was Professor of Logotherapy at the U.S. International University in San Diego California. Frankl's 32 books have been translated into 31 different languages. "Man's Search for Meaning", the English version of "...trotzdem Ja zum Leben sagen", sold millions of copies and was listed as one of the "ten most influential books in America". Grave at Tor 11 (Gate 11), go left 20 metres then continue right for 10 metres.

In the Urnenhain (urn grove) of Clemens Holzmeister's Feuerheiligtum ("fire sanctuary"), which is well worth seeing – Simmering Crematorium lies a few hundred metres north of the main entrance to the cemetery (Tor 2) – in the arcaded passageway along the boundary wall, on the left, is the urn containing the ashes of the anatomist and social politician Julius Tandler (1869 – 1936),

Julius Tandler

whose model social facilities in Vienna were copied throughout the world, and, below number 60, the urn of the radiologist Guido Holzknecht (1872 – 1931) who entered medical history as a pioneer and martyr of his profession.

Art History

Lueger Kirche (Dr. Karl Lueger-Gedächtniskirche)

11th District, Zentralfriedhof / Central Cemetery; Simmeringer Hauptstrasse 234

Opening hours:
daily from 11am to 3pm
(except during funerals and Masses)
Holy Mass: Sundays and holidays: 9am

Tours of the cemetery church are given after Sunday Mass on the first Sunday of the month.

Around 1900 architect Max Hegele (1873 – 1945) drew up the plans for the church dedicated to St Charles Borromeo, the monumental cemetery entrance, the mortuary chapels and the arcades at either side of the church. Between 1904 and 1910 all the designs by this Jugendstil architect, who was aged only 27 when he produced the plans, were carried out. The church which – at least at first glance – is very similar to Otto Wagner's church at Steinhof is however far more massive and deliberately imposing. It is one of the most important Jugendstil buildings in Vienna. Numerous well-known artists contributed to the interior. The mosaics and stained glass windows represent some of the finest work of the period. Now, despite the severe damage suffered in the war, the perfectly restored and renovated church is presented as an almost completely preserved Jugendstil ensemble. The mayor of Vienna at the time, Karl Lueger, who died during the construction work on the church, was laid to rest in the crypt. The church was then given the additional name "Dr. Karl Lueger Memorial Church".

Crematorium

11 District, Simmeringer Hauptstrasse 337

The crematorium of the City of Vienna was built between 1921 and 1923 according to plans by Clemens Holzmeister (1886 – 1983). The crematorium was erected in the grounds of the "Neugebäude", a former imperial summer residence that was destroyed by Hungarian rebels in 1704, later used a munitions depot and was taken down after 1770. Parts of the palace were used in the layout of Schönbrunn park (Gloriette, Römische Ruine). The unusual, vaguely Eastern crematorium building uses details from the still recognisable remnants of this once enormous palace complex. This romantic expressionist early work was Clemens Holzmeister's first building in Vienna and laid the foundation for his career in Austria.

Crematorium

Tour 9

Pharmacy in bloom.
Botanical Gardens of the University of Vienna

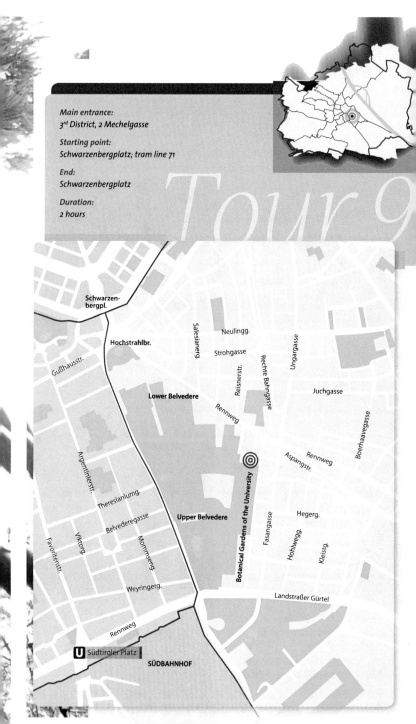

Main entrance:
3rd District, 2 Mechelgasse

Starting point:
Schwarzenbergplatz; tram line 71

End:
Schwarzenbergplatz

Duration:
2 hours

Tour 9

Schwarzen-
bergpl.

Hochstrahlbr.

Gußhausstr.

Salesianerg.

Neulingg.

Strohgasse

Reisnerstr.

Rechte Bahngasse

Ungargasse

Lower Belvedere

Rennweg

Juchgasse

Argentinierstr.

Rennweg

Aspangstr.

Boerhaavegasse

Theresianumg.

Upper Belvedere

Botanical Gardens of the University

Belvederegasse

Fasangasse

Hegerg.

Viktorg.

Mommseng.

Hohlwegg.

Kleistg.

Favoritenstr.

Weyringerg.

Landstraßer Gürtel

Rennweg

U Südtiroler Platz

SÜDBAHNHOF

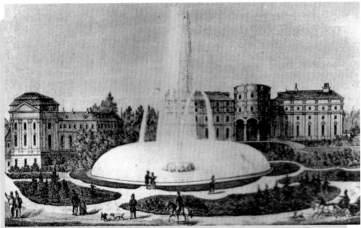

Hochstrahlbrunnen / High-jet fountain.

We begin our tour at the **fountain** on the urban Schwarzenbergplatz, opened in celebration of the completion of the first Viennese mountain spring water supply and, taking the tram 71, we arrive after a short journey at Rennweg from where it is only a short distance on foot to the **Botanical Gardens** of the University of Vienna. Walking back down Rennweg, we turn left into Jacquingasse, then right at the next street until arriving at the main entrance, no. 2 Mechelgasse.

The Hortus Botanicus Vindobonensis is an enormous, wildly romantic open-air museum, with over 9000 exhibits that change almost daily. Botany, as the "scientia amabilis" was an ancillary science to medicine until the middle of the 19th century, and was taught in the medical faculty alongside chemistry as part of the study of medicines. It was only in 1850 that a separate department of

botany was established at the University of Vienna, although scientific botany had been practised in Vienna since the Middle Ages. In 1394, one of the most important physicians of the time,

The gardens.

Galeazzo di Santa Sofia from Padua, was called to Vienna. As well as teaching anatomy there, he would lead his students on so called "herbulations", botanical excursions to the surroundings of Vienna. He had realised that plants could not be studied successfully through books, but only through direct contact with nature. Because these excursions were so laborious and time-consuming, the middle of the 16th century saw the establishment of many botanical gardens, the first being developed at Padua in 1545. These "flowering pharmacies" were so well suited for the tuition of medical students that soon many more academic botanic gardens blossomed in Europe.

The University of Vienna did not acquire its own "botanical garden" until 1754. On the advice of her personal physician **Gerard van Swieten** Empress **Maria**

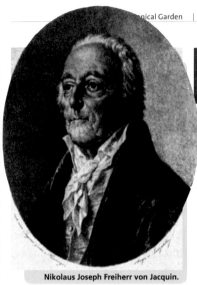

Nikolaus Joseph Freiherr von Jacquin.

Theresa ordered the creation of the "Hortus Botanicus Universitatis Vindobonensis" with the aims of "cultivating native and foreign plants belonging to the palette of healing medicines, and

Beds of herby.

where those assiduously studying medicine should be instructed in the knowledge of the effects of the plants on certain days". Vienna's impressive botanical tradition began in 1768 with the appointment of the well-known physician, chemist, botanist and mineralogist **Nikolaus Joseph Freiherr von Jacquin** (1727–1817) as garden director. Apart from writing some magnificent books with outstanding depictions of plants, he was also the author of "Anleitung zur Pflanzenkenntnis nach Linnes Methode", the foundation for botanical studies at the University of Vienna. Nikolaus Jacquin can be seen as the founder of Vienna's great botanical tradition.

Close to the large pond in the Botanical Garden today stand the **tombstones** of Nikolaus Jacquin and his son Joseph, who followed his father as director. The stones each weigh about a ton, and were brought here in 1976/7 by wheelbarrow (to save money) from the historic gravestone depot of Vienna's local authority. The rubber tyres were squashed

Gardner's house.

flat after transporting this considerable weight. The formation of today's garden can be traced back to the beginning of the last century. The greenhouse complex was set up in 1890, and has sur-

Tombstones of Nikolaus Jacquin and his son.

Plant collection.

Tropical house.

vived almost entirely in its original condition. Restoration of the garden, which was almost completely destroyed in the Second World War, was concluded at the beginning of the 1960s. Medicinal plants, whose cultivation and study was the original main purpose of the garden, are today mostly grown in what is known as the "useful plant garden" in the east of the complex. The commercial cultivation of medicinal plants for the production of medical-pharmaceutical preparations is nowadays carried out in gardens designed for this purpose. Today, the Botanical Garden only cultivates medicinal plants as a study resource for students. In addition to the classic medicinal plants the useful plant garden has a range of common traditional healing plants, a few of which are now enjoying revived popularity.

Besides the medicinal plants, which today make up just a small proportion of the plant collection, the Botanical Garden offers a breathtaking abundance of remarkable plant life. A collection of around 1000 trees, an alpine garden with numerous wild plants taken from the world's mountain ranges, a water basin with native pond vegeta-

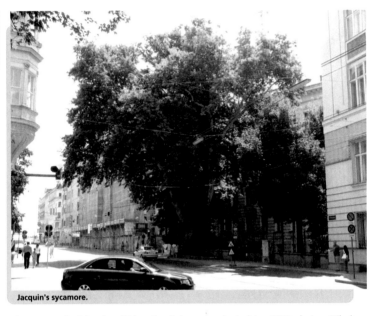

Jacquin's sycamore.

tion, a **tropical basin**, "living fossils" which were already in existence 200 million years ago, vegetables, spices and an abundance of crops, some of which now hold historical significance, leave a striking impression of the variety of the plant life on our planet. Although the Hortus Botanicus Vindobonensis has approximately 9000 different types of plant life, this is just a fraction – around 2 per cent – of the total number of higher plant forms that today exist on earth.

Leaving the Botanical Garden we walk through Praetoriusgasse to return to Rennweg. Upon reaching it, we turn to the left where. in front of the University of Vienna's Botanical Institute building, we see a magnificent ancient tree – known as **Jacquin's sycamore**, which was planted in 1780 during Nikolaus Freiherr von Jacquin's period of office.

We now have two options: To either walk back up to the Rennweg tram stop, and get on the 71 in the opposite direction back down to Schwarzenbergplatz, or to follow Rennweg in the direction of the inner city back to our starting point, passing the Salesian church on our left, and the Garde (or Polish) church on our right, where Masses have been said in Polish since 1782. It was built between 1755 and 1763 by order of Maria Theresia for the Kaiserspital, which had been moved here from the inner city in 1754 and where mostly court staff were cared for. The hospital building behind the church was demolished at the end of the 19th century.

Passing the unassuming entrance to the Lower Belvedere (tour 10), we arrive back at Schwarzenbergplatz.

At Schwarzenbergplatz visitors should not miss the opportunity to take a look at the Hochstrahlbrunnen (high jet fountain). It is not widely known that this fountain is considerably older than the Russian monument behind it (officially called the "liberation monument") and, in fact, has nothing to do with the far younger monument. The fountain was officially opened on October 24th 1873 in celebration of the successful completion of the first Viennese mountain spring water supply, which eradicated the dreaded typhoid fever and gave Vienna what is considered the world's best drinking water. The company of Anton Gabrielli, which built the pipeline from the Schneeberg mountain range to the city also sponsored and built the fountain. Surrounding the huge central fountain are the smaller fountains, arranged to represent the calendar – 365 small spouts at the rim, 6 between the rim and the island for the weekdays, 12 high jets for the months, 24 medium jets for the hours and 30 smaller jets for the days of the month. In 1906 lighting was installed in the fountain. The monument to the Red Army was inaugurated only after the Second World War, on August 19th 1945.

Another exceptional rarity to be found on Schwarzenbergplatz is **Vienna's smallest vineyard**. 75 vines grow in the middle of the city on an area of around 170 square metres. The vineyard is looked after by the winegrow-

Vienna's smallest vineyard
Schwarzenbergplatz 2.

ers "Mayr am Pfarrplatz" from Heiligenstadt. The grapes are harvested by city's VIPs, led by the mayor of Vienna. The 60 to 70 bottles filled yearly are auctioned at Christmas time, and the money thus raised is given to charity.

Botanical Gardens of the University of Vienna

Opening times:
From Easter until 26 October,
daily from 9am till dusk.

Art History

Salesian Church of the Visitation of Mary

The widow of Emperor Joseph I, Empress Amalia Wilhelmine, brought nuns from the Order of the Visitation of Mary, more commonly known after their founder, St. Francis de Sales, as the Salesians, from Brussels to Vienna and acquired for them a building with a garden on Rennweg. She thus founded the convent, an educational establishment for girls from noble families that was attached to it and also erected the place where she spent her widowhood. Until her death in 1742 the emperor's widow lived in the right-hand wing of the convent. The foundation stone for the church and convent was laid on the day Maria Theresia was born, 13 May 1717, and the basic structure was handed over to the Salesian nuns in 1719. It was not until 1730 however that the church was finally completed and dedicated. The construction was headed by Donato Felice d'Allio, it is also possible that Johann Bernhard Fischer von Erlach (1656–1723), who designed many of Vienna's finest buildings, was involved in the design of the façade. The interior of this oval domed building is regarded as one of the loveliest Baroque church interiors in Vienna. The foundress of the church is buried under the high altar. Parts of the convent buildings are used today by the University of Music and Performing Arts.

Gardekirche Hl. Kreuz, formerly Kaiserspitalkirche, Polish National Church

The Kaiserspital (Imperial Hospital) was moved from Ballhausplatz in the inner city to Rennweg in 1754. One year later Maria Theresia had a new hospital church built by her favourite architect Nicolaus Pacassi. The church was completed and dedicated in 1763 but in 1769 it was given a complete renovation and the façade was altered to suit the taste of the time. After the Kaiserspital was closed down in 1782 Emperor Joseph II handed the church over to the Polish Life Guards. Since the demolition of the Kaiserspital in the years 1890-98 the church has belonged to the Congregation of the Resurrection and is the Polish National Church. The interior dates for the most part from the 18th century and has been augmented by loans from the Schlosskapelle in Schönbrunn Palace and from the Kunsthistorisches Museum. Pope John Paul II blessed the modern organ on the occasion of his first visit to Vienna in 1983. There is a bronze statue of this Polish pope to the right of the church entrance.

Art History

Schwarzenbergplatz

1st and 3rd Districts

The square planned according to Heinrich von Ferstel's concept as a magnificent setting between the Ring and Lothringer Strasse for the Schwarzenberg Monument gradually developed beyond this original concept. The centre point is formed by the equestrian statue, unveiled in 1867, of Field Marshall Prince Karl Philipp Schwarzenberg, the "victorious leader of the allied armies against Napoleon", according to the inscription on the monument, – in the Battle of Leipzig in 1813. Six mighty palaces form a kind of *cour d'honneur* around this monument. The most elegant and noble palace, and also the first to be erected on the newly laid-out square, was the palace designed by Ferstel between 1863 and 1867 for Archduke Ludwig Viktor who celebrated many lavish parties there. After Emperor Franz Joseph banished Ludwig Viktor, his youngest brother, to Schloss Klesheim near Salzburg on account of the latter's "scandalous" lifestyle – he was homosexual – in 1910 the emperor handed the building over to the military casino, an academic military association with a large library. Since the beginning of the 1980s the "Kasino on Schwarzenbergplatz" has been used as a venue for rehearsals and performances by the Burgtheater.

Directly next to this building, in front of no. 2 Schwarzenbergplatz, is Vienna's smallest vineyard. The wines from these 75 vines achieve legendary prices each year at an annual charity auction.

The palatial buildings opposite (nos. 16 and 17 Schwarzenbergplatz) were built by Ferstel as a home for the industrialist Franz Freiherr von Wertheim, who achieved fame with his fireproof money safes. On the occasion of the production of the 20,000th "feuerfeste Casse" (fireproof safe) a huge celebration was held here, for which Josef Strauß wrote his *Feuerfest Polka*.

After Lothringerstrasse the square expands into a funnel shape and ends at the Hochstrahlbrunnen (high jet fountain) that was built in 1873 on the completion of the springwater supply, the Russian liberation monument erected in 1945 behind it.

Restaurants

🍴 Gasthaus Seidl

1030 Vienna, Ungargasse 63
Tel.: 713 17 81
Monday to Friday 10am to 11pm

🍴 Salm Bräu

1030 Vienna, Rennweg 8
Tel.: 799 59 92
Daily 11am to 12 midnight

Art Collections
 of the Belvedere
Tour 10

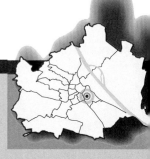

Starting Point
Opera House; tramline D travelling towards Südbahnhof

End:
Schwarzenberglatz

Duration:
3 hours

Tour 10

Schwarzen-
bergpl.

Hochstrahlbr.

Gußhausstr.

Lower Belvedere

Salesianerg.

Neuling.

Strohgasse

Reisnerstr.

Rechte Bahngasse

Ungargasse

Juchgasse

Boerhaavegasse

Rennweg

Argentinierstr.

Theresianumg.

Belvederegasse

Upper Belvedere

Mommseng.

Botanical Gardens of the University

Aspangstr.

Rennweg

Fasangasse

Hegerg.

Hohlwegg.

Kleistg.

Favoritenstr.

Viktorg.

Weyringerg.

Landstraßer Gürtel

Rennweg

U Südtiroler Platz

SÜDBAHNHOF

Wrought-iron gate, Upper Belvedere.

Schloss Belvedere, south front.

At the tram stop Oper, on the Ring directly opposite the Opera House, we wait for a D tram running in the opposite direction to the main flow of traffic on the Ring and travelling towards Südbahnhof railway station. The "Elektrische" (electrical), as it is familiarly known in German, runs across Schwarzenbergplatz and up Prinz Eugen Strasse where it conveniently stops directly opposite the entrance to **Schloss Belvedere**. We are now standing in front of the west wing of the Upper Belvedere, which was used by the great Austrian military commander and politician **Eugene of Savoy** (1663 – 1736) for festivities and formal entertaining. The prince's summer palace – itself anything other than plain – was the Lower Belvedere. These two palaces, which are regarded as some of the finest exam-

Schloss Belvedere, north side.

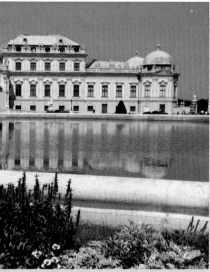

View of Vienna from the Belvedere.

ples of profane Baroque architecture, are connected by a unique park with ponds, fountains and garden sculptures. After the death of Prince Eugene the Empress Maria Theresia acquired the palace, gave it the name Belvedere and had the imperial and royal collection of paintings moved there from its previous home in the Stallburg. Under her son Joseph II the imperial painting gallery was opened to the public from 1781 onwards.

The entire ensemble is a Baroque *gesamtkunstwerk* that is today regarded as one of the most beautiful historic palace and garden complexes in the world. On a clear day there is a breathtaking **view of Vienna** from the north side of the palace. On 15 May 1955 the foreign ministers of the four allied pow-

Memorial plaque to Anton Bruckner.

Prince Eugene's menagerie.

ers – the USA, the Soviet Union, Great Britain and France – signed the Austrian State Treaty in the Marble Hall of the Upper Belvedere. From the balcony of this hall the Austrian foreign minister **Leopold Figl** proclaimed to the cheering crowd below: "Austria is free!"

The collections of the Belvedere span from the Middle Ages to the present day. The museum in the Upper Belvedere offers a fantastic overview of Austrian and international art from Viennese Biedermeier and Classicism to masterpieces of French Impressionism or 20th century Expressionism.

Before we stroll through the magnificent gardens to the Lower Belvedere we will walk around to the south side of the palace where a fine wrought iron gate and (when the weather is good) a marvellous reflection of the façade in

a large pool of water made expressly for this purpose compensate us for the small detour. Beneath this pool there is still a bunker complex from the Second World War that, towards the end of the war, contained a military hospital, but, as this is a secret, please don't pass it on. To build this bunker – as one can still clearly see today – the pool had to raised about a metre, which impaired the reflection of the palace façade in the water. In the east wing, known as the *Kustodentrakt* a plaque commemorates the fact that the composer **Anton Bruckner** (1824 - 1896) spent the last years of his life here and also died here. The prince's **menagerie** or zoo was to the east of the Upper Belvedere. Here the first giraffes to be brought to Vienna alive were kept, as well as a famous lion said to have died in the same night as Prince Eugene.

Franz Xaver Messerschmidt.

But now we are finally going to walk through the classic French garden down to the Lower Belvedere, the prince's summer residence. In addition to the attractions of the Museum of Mediaeval Art in the Orangery, the Baroque Museum that is housed in the prince's opulently decorated living and reception rooms offer a unique opportunity to view excellent pieces of Baroque art in a setting that dates from the same period.

Here is where the Belvedere acquires interest from the viewpoint of the history of medicine. There is a Baroque sculptor who down to the present day has continued to fascinate not only art historians and artists but also psychiatrists and psychologists: **Franz Xaver Messerschmidt** (1736 - 1783). After training in Munich and in Graz Messerschmidt's

name is found for the first time in 1755 in the list of students at the Academy in Vienna. The highly talented but penniless student initially earned money as a decorator of the cannon foundry in the Viennese Zeughaus (arsenal). The extraordinary quality of his busts of Maria Theresia and her spouse that were intended for the Zeughaus established this artist's reputation and led to him being given further commissions by members of the aristocracy.

The bust of Gerard van Swieten, the empress' personal physician, which was ordered by Maria Theresia herself, is regarded as an excellent example of Messerschmidt's portrait sculpture. Messerschmidt completed the bust in 1769. In 1889 it was moved from the Allgemeines Krankenhaus (General Hospital) to the Arkadenhof of Vienna University

Hochstrahlbrunnen / High-jet fountain.

and a strange story is told about it: apparently two men dressed in workmen's clothing carried away the bust made of gilded lead, without being questioned by anybody! Luckily, it later surfaced on the art market and since then a bronze cast of the original has stood on the original plinth in the Arkadenhof, the original bust is now on display in the Baroque Museum.

In 1769 Messerschmidt was elected a member of the Academy and was appointed deputy professor of sculpture. It was around this time also that his psychiatric illness developed. On account of his "strange health" Messerschmidt received early retirement and lost any further commissions from the court in

Vienna. His glittering career suddenly ended. Irritated and disappointed he left Vienna and retired to Pressburg, nowadays known as Bratislava. There Messerschmidt began to produce the works for which became famous, albeit only posthumously, his series of "character heads". These heads with faces distorted by grimaces have given this sculptor the reputation of being a "psychopathic" artist and have attracted the attention not only art historians but also of psychiatrists and psychoanalysts.

None of these heads was a commissioned piece, and not a single one was sold during the artist's lifetime. For Messerschmidt these busts were not merely artistic works but faces that he had to have around him to frighten off

and banish the ghosts that tormented him. Messerschmidt, whose illness remains a matter of intense discussion but could possibly be interpreted as schizophrenia, could, so to speak, heal himself with his art. He retained his creative strength and his powers of observation to the end. Written off as an oddball he died of pneumonia in Pressburg in 1783, at the age of only 47.

Since 1793 his "character heads" have been regularly exhibited as curiosities and on the occasion of the first exhibition in the Viennese Bürgerspital they were given invented titles. Messerschmidt himself left us no titles for his heads. The extensive literature and the studies made of the "character heads", also by contemporary visual artists, prove – and everyone can convince themselves of this fact in the museum – that these works created for the purpose of self-healing still exert an immense fascination. Of a total of 69 heads with their mix of anatomical correctness and grotesque grimaces that make an astonishing, at times comical but at other times frightening, impression on the viewer the Baroque Museum owns 16 originals and a number of plaster casts of others. The "Schnabelköpfe" (literally "beak heads") occupy a special position within this series. They have a totally deformed physiognomy and seemingly had a very special meaning for the artist. The poet Nikolaus Lenau remarked about Franz Xaver Messerschmidt: "...there must have been something about this sculptor that could have easily turned him into an idiot, fortunately in his case it expressed itself as art."

We leave the museum and the park and come onto Rennweg where we can take the 71 tram to the Ring or slowly make our way on foot heading left towards Schwarzenbergplatz with the **Hochstrahlbrunnen** (High Jet Fountain, see Tour 9). Since 1880 this Platz or square has been named after **Karl Philipp Prince Schwarzenberg** whose Baroque palace – today an exclusive hotel and restaurant – is situated in a large private park directly behind the Russian liberation monument.

Art Collections of the Belvedere

3rd District
Prinz Eugen-Strasse 27

Upper Belvedere

Collections of 19th and 20th Century Art
3rd District
Prinz Eugen-Strasse 27

Lower Belvedere

Baroque Museum and Museum of Mediaeval Art
3rd District
Rennweg 6a

Café Restaurant Schloss Belvedere

1030 Vienna, Upper Belvedere
Tel.: +43/1/79 557-168
Tuesday to Sunday 10am to 18pm

Schönbrunn
Tour 11

Starting point:
U4 Underground station Karlsplatz or tram 58
from Westbahnhof

End:
U4 Underground station Hietzing,
exit Kennedybrücke

Duration:
around 3 hours

Tour 11

Schönbrunner Schloßstrasse

Schönbrunn Palace

Palm House

Maxingstrasse

Zoological Garden

Neptune Fountain

Gloriette

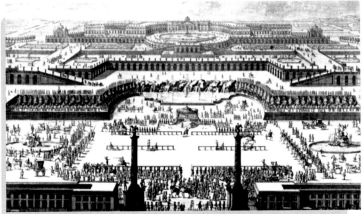

The first design for Schönbrunn Palace.

Although Schönbrunn is perhaps only of very marginal medical historical interest, you simply must include a visit to this magnificent Baroque palace complex. Schönbrunn can be reached most quikkly by the U4 Underground line. From the station *Schönbrunn* it is only a few metres to the main entrance to the palace grounds that is flanked by two obelisks. Napoleon had the golden French **imperial eagles** mounted on top of

the obelisks in 1805 when, to humiliate the Habsburgs, he chose Schönbrunn as his residence. In front of us at the far end of the *cour d'honneur* measuring 24,000 square metres in area is Vienna's most popular tourist sight that attracts millions of visitors every year: the magnificent Baroque *gesamtkunstwerk* Schönbrunn.

Those with more time at their disposal are recommended to take the tram line 58 to Schönbrunn from Westbahnhof. At the end of Mariahilfer Strasse one passes the house in which **Alfred Adler**, Austria's most famous psychoanalyst after Sigmund Freund and the founder of individual psychology and the discoverer of the inferiority complex, was born, in no. 208 Mariahilfer Strasse now

a sadly run-down building. On the right hand side, at the tram stop *Anschützgasse*, there is a memorial plaque above the entrance to the house, easily visible from the tram. After passing the Technical Museum on the right, the tram turns to the left and suddenly Schloss Schönbrunn with its vast courtyard lies in front of us in all its Baroque glory. From the tram stop *Schönbrunn* it is only a few steps to the main entrance. If you travel with the 10A bus you see a similar view.

Eagle on an obelisk.

Like every historic building worth its salt, Schönbrunn also has its own legend. It is said that in 1612 when the **Emperor Matthias** was hunting along the right bank of the river Wien (the area with a large manor house, pleasure garden and menagerie had been acquired by his father **Maximilian II** in 1569) he discovered a "schöner Brunn (beautiful spring or source) with excellent drinking water. Decades later this spring was to give the summer palace its name. Until the construction of the first Viennese mountain source water supply line in 1873 this spring supplied the Viennese court with drinking water. Inside the **romantic fountain** house, the nymph Egeria still pours this highly esteemed water out of an urn into a basin. A stone slab engraved with the letter "M" with a crown over it commemorates the person who discovered the beautiful spring.

Until the Turkish sieges of Vienna the hunting lodge that Maximilian II built here was home to two widowed empresses and the venue for magnificent celebrations. During the second Turkish siege in 1683 the palace was practically completely destroyed. **Emperor Leopold I**, who had inherited it in 1686, decided not to repair the devastated building but to erect a fittingly impressive new palace. The first plans by the well-known architect **Johann Bernhard Fischer von Erlach** was for a vast palace landscape that started at the top of the Schönbrunner Schlossberg, the hill where the **Gloriette** now stands, and cascaded like a wave down the entire slope with ramps, water features, colonnades and huge terraces. This enormous complex – possibly a utopian design with which the architect wished to demonstrate his ability and to attract the emperor's interest – was never built.

Gloriette.

Neptune Fountain and Gloriette.

A very different project was erected: a considerably smaller hunting lodge on the flat area of the site with a large cour d'honneur and an obelisk gate to the north. Only the palace chapel and the blue staircase from this building survive. The two bronze groups of figures – in fact stoves – in the entrance driveway probably date from this time. Not all the Habsburgs showed great interest in Schönbrunn. For decades it was used only for occasional hunting expeditions. It was the **Empress Maria Theresia** that made it into her favourite summer residence. She was responsible for the conversion and extension works that made it into her residence and gradually the building acquired its present-day distinguished appearance. **Franz Joseph I**, the husband of Empress Elisabeth (Sisi), was born here in Schönbrunn, lived with Sisi in the west wing and also died here in 1916 during the First World War. Schönbrunn Palace remained the imperial summer residence until the end of the monarchy in 1918. It subsequently came into the possession of the Republic of Austria.

Behind the palace the large park extends towards the south to the Gloriette on the Schönbrunner hill. The park has been open to the public since 1779 and since then has been a favourite recreation area for the people of Vienna and a unique tourist attraction. There are many different ways to discover the palace park. The only factor that restricts us here is the amount of time available. Where time is of the essence I recommend a short tour from the Schloss to the Hietzinger Gate that documents the Habsburgs, interest in the natural sciences and, at the close, even allows us end the tour on a medical historical note. Let us start our walk at the

Romantic fountain.

centre of the garden front of the palace. This is the point where the mighty diagonal alleys meet the centre axis of the palace. In front of us the flower beds of the large parterre are arranged in strict symmetry and in patterns reminiscent of embroidery. The large **Neptune fountain** at the far end of the flowerbeds is most impressive and on the top of the Schönbrunner Hill the Gloriette occupies a dominant position. The central path divides the garden into two functional halves. To the left is the ornamental garden, which you reach along the diagonal avenue on the left and which offers romantic details such as the grotto-like building housing the "Beautiful Spring", the unusual Obelisk Fountain and the Roman Ruin. The section of the park to the right is devoted to the natural sciences and contains the zoological gardens – incidentally the oldest of its kind – the **Palm House**, and the Botanical Gardens. Whereas Maria Theresia devoted herself largely to the development and decoration of the palace, her spouse **Franz I Lothringen** took care of the design of the garden.

The Emperor, who took a keen interest in the natural sciences, founded the *Schönbrunn Menagerie* in 1752 – twelve animal enclosures are arranged radially around a central pavilion from which the imperial couple could observe the exotic animals – and a year later he had the *Holländisch-Botanischer Garten* (Dutch Botanical Gardens) laid out on the western edge of the palace park.

From the centre of the palace facade we continue along the centre axis across the large parterre where the axis ends in front of the mighty Neptune fountain – a huge basin with a rocky landscape in which the god of the seas disports with his entourage. On either side of the Neptune fountain a path zigzags up the hill to the Gloriette which has a viewing terrace that offers a magnificent view across Schönbrunn and over the city. But we take a turn to the right and walk along the side of the zoo about 500 metres to the Palm House. The site of the present day Palm House was once occupied by the *Holländischer Garten*, a botanical garden with a greenhouse that Emperor Franz I Stephan had laid out in 1753 by the Dutch gardener **Adrian van Steckhoven** – who was called to Schönbrunn on the advice of the imperial physician Gerard van Swieten. Through the involvement of well-known botanists in the Holländisch-Botanischer Garten this garden acquired a worldwide reputation. Lengthy scientific expeditions commissioned by the emperor not only brought exotic plants but also live animals to Vienna. From his West Indies expedition **Nikolaus Jacquin**, later to become professor of botany and chemistry, brought back to Schönbrunn fifty crates with medicinal and poisonous plants, tropical trees and, as well as rare cacti and exotic birds for the emperor's menagerie. Later the Emperors Joseph II, Franz I and Franz II enlarged the park through the acquisition of sites, built a number of greenhouses and planted an arboretum for study purposes. Four mighty plane trees near the Palm House date

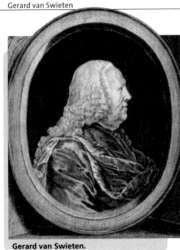

Gerard van Swieten.

from this time. The new botanical garden was laid out in 1845 along the west wall of the park. Even if time is short visitors should not miss the last and largest palm house on the European continent. The imposing iron structure which makes a light and aesthetic impression was completed in 1881/82. Three distinct but connected pavilions with three different climatic zones – Mediterranean, tropical and subtropical – allow rare plants from throughout the world to be cultivated and displayed here.

Towards the end the tour becomes more interesting from the viewpoint of medical history. To the right of the Hietzinger Gate exit is a building known as the Kaiserstöckl. In 1751 when the site still lay outside the confines of the park, Maria Theresia had it built as a home for her personal physician **Gerard van Swieten** – the radical reformer of the study of medicine in Vienna and the founder of the 1st Viennese me-

dical school. As a doctor Van Swieten was primarily a dietician and there is an anecdote about his practice at court in which he drastically demonstrated to the overweight Empress Maria Theresia her fondness for rich, difficult to digest meals. At a table the physician ordered a lackey to place a pail beside his chair. During the meal van Swieten took roughly the same amount of each dish as the empress and threw it into the pail. The empress asked in astonishment: "But pray, van Swieten, what is this supposed to mean?" Van Swieten allowed the empress a brief look at the by now rather unappetising mess and said: "This is how it now looks in your Majesty's stomach!" This vivid demonstration is said to have more effect on the empress than all previous warnings to eat a more moderate diet.

At the end of March 1772 van Swieten, who was already sickly, developed a small sore on a toe out of which a little bloody pus oozed. After a few days this toe went black and had to be amputated. Shortly after this the sore appeared on another toe and a few days later the entire foot was *brandig* (fiery) or gangrenous, as we say today. On 18 June van Swieten died, mourned by the empress, here in this house in Schönbrunn. His tomb, with a marble bust donated by Maria Theresia, is in the Augustinerkirche.

After leaving through the Hietzing Gate we turn right and after a few minutes arrive at Kennedybrücke, where either the U4 or a tram can bring us back into the city.

Information

Schloss Schönbrunn/Schönbrunn Palace

opening hours
1 April – 30 June: 8.30am – 5pmr
1 July – 31 August: 8.30am – 6pm
1 September – 31 October: 8.30am – 5pm
1 November – 31 March: 8.30 – 16.30pm
Tel.: +43-1-81113 239
Fax.: +43-1-81113 333
Email: schauraeume@schoenbrunn.at
www.schoenbrunn.at

Opening hours of the park:

Visitors may enter the park until 30 minutes before evening closing time
1 April – 31 October: from 6am
1 November – 31 March: from 6.30am

The gates of the park are closed at the following times

27 February – 05 March: 6pm
6 March – 19 March: 6.30pm
20 March – 26 March: 7pm
27 March – 30 April: 8pm
1 May – 21 May 8.30pm
22 May – 06 August: 9pm
7 August – 20 August: 8.30pm
21 August – 03 September: 8pm
4 September – 17 September: 7.30pm
18 September – 2 October: 7pm
3 October – 29 October: 6.30pm
30 October – 04 March (2007): 5.30pm

Palm House: opening hours

May – September: 9.30am – 6pm
October – April: 9.30am – 5pm

Zoo: opening hours:

January: 9am – 4.30pm
February: 9am – 5pm
March: 9am – 5.30pm
April: 9am – 6.30pm
May: 9am – 6.30pm
June: 9am – 6.30pm
July: 9am – 6.30pm
August: 9am – 6.30pm
September: 9am – 6.30pm
October to the end of summer time: 9am – 5.30pm
November: 9am – 4.30pm
December: 9am – 4.30pm

Desert House: opening hours:

January – April: 9am – 5pm
May – September: 9am – 6pm
October – December: 9am – 5pm

Gloriette viewing terrace:

1 April – 30 June: 9am – 6pm
1 July – 31 August: 9am – 7pm
1 September – 30 September: 9am – 6pm
1 October – 31 October: 9am – 5pm

Hours during which the fountains play:

Neptune fountain: 10am – 2pm
Park fountains: 8.30am – 8.30pm
Orangery garden: 8.30am – 8.30pm
Cour d'honneur (entrance forecourt): 8.30am – 8.30pm
Roman Ruins: 10am – 4pm
The fountains do not operate during the winter season: mid-October to April

⑪ Café Gloriette

1130 Vienna, Schlosspark Schönbrunn (Gloriette)
Tel.: 879 13 11
Daily 9am until one hour before the park closes

⑪ Café Dommayer

1130 Vienna, Auhofstrasse 2 (Dommayergasse)
Tel.: 877 54 65
Daily 7am to 10pm

Monument
to a dream
Tour 12

Starting point:
U4 Underground station Heiligenstadt, bus 38 A to car park Cobenzl, then about a 20-minute walk to Bellevuehöhe.

End:
U4 Underground station Heiligenstadt

Duration:
3 hours

Tour 12

Cobenzlg.

**car park
Cobenzl**

Höhenstr.

Höhenstr.

Himmelstr.

Am Himmel

Paul-Wessely-Weg

Reisenbergbach

**Bellevue
Höhe**

Bellevue

Bellevuestr.

Sigmund Freud.

Freud and Fließ.

The only reason that Bellevue has not become a place of psychoanalytical pilgrimage is its distance to the city of Vienna. It is located at a place known as Himmel (literally: heaven) that lies at the end of Himmelstrasse in the 19th district, and is difficult to reach for those who rely on public transport. But overcoming our laziness, we take the 38A bus from the terminus of the U4 Underground line at Heiligenstadt, and get off at Cobenzl car park about 20 minutes later. After leaving the car park we turn right and, after about 400 metres, we come to Himmelstrasse on the left which we follow until we reach a small car park on the right. The monument to what is probably the world's most famous dream is to the left on a broad meadow that lies somewhat above the car park.

July 24, 1895 is not just one, but *the* milestone in the history of psychoanalysis. On this day Sigmund Freud was successfully able for the first time to completely analyse his own dream. He was staying at the **spa hotel Bel-**

BELLE VUE.

levue, which at that time stood on this meadow, when on the night of July 23/24 he had the dream of "Irma's injection". Five years later, Freud published this dream in the book that was to become his major work: **Traumdeutung** (The Interpretation of Dreams). On 12 June 1900 Freud wrote light-heartedly to his long-standing friend and colleague **Wilhelm Fliess** in Berlin wondering: "Do you suppose that some day a **marble tablet** will be placed on the building, inscribed with the words: "In this building on July 24 1895, the secret of dreams was revealed to Dr. Sigmund Freud"? "At this moment I see little prospect of it".

A marble tablet was not mounted on the hotel Bellevue – the building was demolished after the Second World War, and all that now remains of the former

DIE

TRAUMDEUTUNG

VON

DR. SIGM. FREUD.

»FLECTERE SI NEQUEO SUPEROS, ACHERONTA MOVEBO.«

LEIPZIG UND WIEN.
FRANZ DEUTICKE.
1900.

"Traumdeutung" appeared in 1899.

Marble stele with inscription.

mansion is the beautiful view – however at the end of a short stone-paved path, at a point in front of the building where Freud had his dream, there is a marble stele where the above quotation from the letter is engraved on a bronze plaque. Freud's daughter Anna came to Vienna on May 6th, 1977 especially for the unveiling of the monument at the "cradle of psychoanalysis"

Freud spent several summers in the hotel Schloss Bellevue that was a popular destination for excursions in fin-de-siecle Vienna and was located at the end of the Himmelstrasse, which leads steeply upwards from Grinzing into the Vienna Woods. He often spent holidays there with his family. He loved the splendid view over Vienna and the pleasant life in the 18th century mansion: "Life at Belle Vue is most pleasant for everyone; the scent of acacias and jasmine now follow those of lilac and laburnum, the dog roses are blossoming and all this happens, as I can observe, very suddenly." It was in this ambiance that Freud had his crucial experience. On the night of June 23 1895 he dreamt the dream that was to go down in the annals of psychoanalysis as the "Dream of Irma's Injection". He succeeded "directly after awakening" in completely decoding, analysing all details, and solving the "meaning" of the dream. For Freud, the analysis of this dream was evidence that dreams are not meaningless, but a genuine wish fulfilment, and that the motive of every dream is a wish.

Subsequently Freud analysed many of his own and his patients' dreams and found more and more proof for his theory of dreams. He made himself the object of his examinations and his "most important study subject". Through the investigation of dream language and dream interpretation he tried to find a way into the depths of the psyche to utilize his findings in the treatment of neuroses. It was around this time that Freud also started using the term "psychoanalysis". In 1897 he was already so convinced of his dream theory that he wrote to Fliess: "It seems to me I'm like Rumpelstiltskin and that absolutely nobody understands that the dream is not nonsense, but wish fulfilment". He decided at the end of May 1899 to publish "Traumdeutung" (The Interpretation of Dreams), a book he had been working on for a long time. In this work Freud not only analyses dreams but also gives an insight into his technique of dream analysis. He separates the dream into single pieces and then starts to freely associate each part of the dream. It was his spontaneous ideas and not logical intellect that allowed him grasp the meaning of the dream.

The book appeared in November 1899 but was dated 1900 and was published by Franz Deuticke of Vienna. As a maxim Freud chose a verse from Virgil's Aeneid: "If I cannot move the heavens, I want to rouse the underworld". This is the first great work of psychoanalysis. However, sales of the book were slow, and it took eight years for the 600 copies of the first edition to be sold. Recognition from both the public and scientific community failed to materialise. At the time the book was compared

with the popular dream books, with which those who played the national lottery hoped to find their lucky numbers. "Traumdeutung" was hardly discussed at all in professional journals and was largely ignored both in Vienna and abroad. Freud's dream of being given a professorship at the University of Vienna remained unfulfilled.

Rejection and ignorance could not shake Freud's conviction that he had discovered something of worldwide importance. And he was right: "Traumdeutung" is his greatest and most important book. It is also one of the few works every reprint of which Freud carefully revised. It is a classic work, not only for psychoanalysis but also for almost all areas of daily life in the 20th century. Freud had found the riddle and then solved it. Without "Traumdeutung", many areas of art, literature, painting and the cinema would today be inconceivable. Even if Karl Kraus mocked that psychoanalysis is the illness for which it regards itself as the therapy, practically all forms of the humanities were and

will continue to be influenced by psychoanalysis in one form or another.

The "Dream of Irma's Injection" marked the beginning of this development. A dream that takes up 17 pages of analysis in "Traumdeutung", a dream that is familiar to every analyst today and has become a treasure trove for speculation about Freud's inner life. With the meticulous analysis of this dream, Freud had found his ideal way into the subconscious. It was this dream that pointed the way to his comprehensive theory of the unconscious. Freud dreamt this dream in the hotel at Bellevue, and if the hotel still existed it would be a Mecca for today's analysts and the room that Freud stayed in its Kaaba. Today a single marble stele on an open meadow – with one of the most beautiful views over Vienna, and an excellent place to lie back and relax – commemorates that memorable day on which the foundation stone was laid, not only for one of the most revolutionary books of the 20th century but for the entire field of psychoanalysis.

Tour 13

The muscle man and the wax Venus

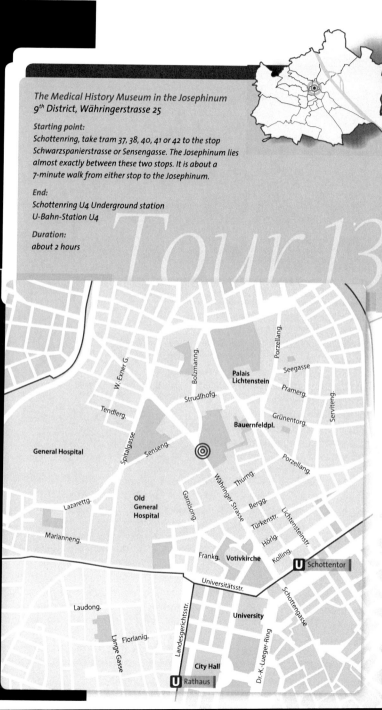

The Medical History Museum in the Josephinum
9th District, Währingerstrasse 25

Starting point:
Schottenring, take tram 37, 38, 40, 41 or 42 to the stop
Schwarzspanierstrasse or Sensengasse. The Josephinum lies
almost exactly between these two stops. It is about a
7-minute walk from either stop to the Josephinum.

End:
Schottenring U4 Underground station
U-Bahn-Station U4

Duration:
about 2 hours

Tour 13

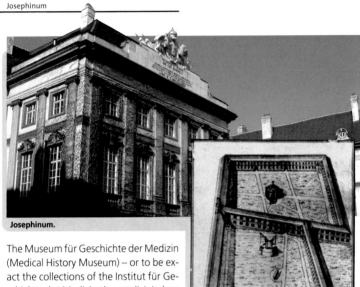

Josephinum.

Josephinum with Garrison Hospital.

The Museum für Geschichte der Medizin (Medical History Museum) – or to be exact the collections of the Institut für Geschichte der Medizin der medizinischen Universität Wien (Medical History Institute of the Medical University of Vienna) – is housed in what is probably Vienna's most beautiful functional building, the **Josephinum**. This palatial building, with its U-shaped *cour d'honneur*, was built by order of **Emperor Joseph II**, and is regarded as the main work of architect **Isidore Canevale**, who received a number of commissions in Vienna at that time. On November 7, 1785 Joseph II opened this facility, which was originally the Medizinisch-Chirurgische Militärakademie (Military Medico-Surgical Academy) or Josephs Akademie (Joseph's Academy), a training centre for army doctors. For the practical training of field surgeons the 1200-bed **Garnisonsspital** (Garrison Hospital) was attached to the rear of the academy. Joseph II, who was very aware of the deplorable condition of the medical services in his army, wanted to pro-

vide a theoretical and academic education for army doctors who at that time were trained only in the practical skills required to treat wounds. He wanted to train so-called medico-surgeons for his soldiers and their relatives, who would have a comprehensive knowledge of internal medicine, surgery and obstetrics. Although there were regularly good teachers at Joseph's Academy, it never really gained acceptance. It closed several times, and finally, after surgeons were granted equal recognition to doctors and the qualification doctor of gen-

Billroth stomach resections.

eral medical science was introduced, it was shut down permanently in 1874. The facility then housed institutes for advanced military medical training until the collapse of the monarchy, and in 1920 the Institut für Geschichte der Medizin (Medical History Institute) moved into the historically important medical rooms. The treasures of the house, the Josephinum library, valuable instruments and, most importantly, the anatomical and obstetric wax models came into the possession of the institute. In addition to the important scientific work carried out there this inheritance has given the Viennese medicine historical institute worldwide fame.

The museum, which has also been in existence since 1920, is primarily a museum of Viennese medicine. Numerous unique documents, pictures, books and objects illustrate the development of Viennese medicine from the beginning of clinical tuition under **van Swieten** and **de Haen** in the University Clinic, established in 1745 at the Bürgerspital

(Citizens' Hospital, see tour 2), to the new specialised subjects of obstetrics and ophthalmology set up at the Allgemeines Krankenhaus (General Hospital, see Tours 4 and 5) and the successes and discoveries made by the Viennese medical school in the 19th and early 20th century that astounded and enriched the medical world. Among the particularly attractive objects is an almost complete set of surgical instruments that Joseph II had made for his academy, in red leather cases lined with green velvet. There are also pieces of virtually "world heritage value in the field of medicine" to be found here. These include a skull personally inscribed by the phrenologist Franz Gall; the legendary washbasin from the clinic where **Ignaz Semmelweis**, "the saviour of mothers", worked; the operation and autopsy specimens of the first **stomach resection** carried out by **Billroth** on January 29th 1881, **Clemens von Pirquet's** tuberculin lancet, and the first dialysis machine developed by **Bruno Watschinger**.

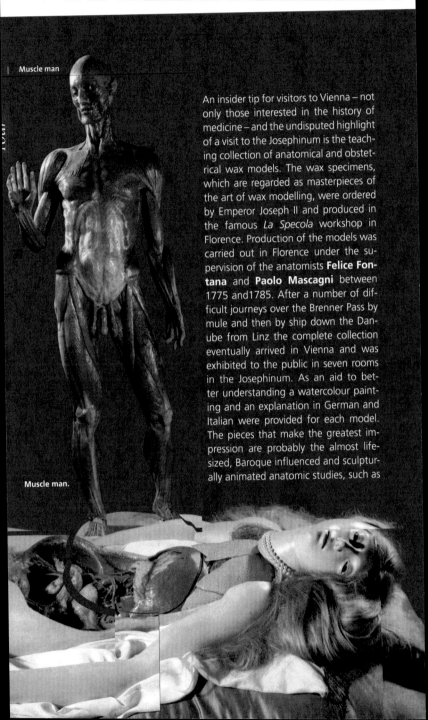

Muscle man.

An insider tip for visitors to Vienna – not only those interested in the history of medicine – and the undisputed highlight of a visit to the Josephinum is the teaching collection of anatomical and obstetrical wax models. The wax specimens, which are regarded as masterpieces of the art of wax modelling, were ordered by Emperor Joseph II and produced in the famous *La Specola* workshop in Florence. Production of the models was carried out in Florence under the supervision of the anatomists **Felice Fontana** and **Paolo Mascagni** between 1775 and1785. After a number of difficult journeys over the Brenner Pass by mule and then by ship down the Danube from Linz the complete collection eventually arrived in Vienna and was exhibited to the public in seven rooms in the Josephinum. As an aid to better understanding a watercolour painting and an explanation in German and Italian were provided for each model. The pieces that make the greatest impression are probably the almost life-sized, Baroque influenced and sculpturally animated anatomic studies, such as

the **muscle man**, the **lymphatic man** or the **Medici Venus** with her flowing blond hair, double-row pearl necklace and removable entrails. The obstetrics collection that consists of 102 objects is the largest of its type in the world. Even if sometimes the anatomy is no longer completely correct – Mascagni, who was investigating the lymphatic system at the time, exuberantly provided the models with lymphatic vessels where in fact there are none at all – the collection still has immense didactic value just as it did two hundred years ago. No photograph can convey the spatial relationships and proportions of the organs, muscles, vessels and nerves so impressively.

In addition to this world-famous collection, the Josephinum also houses the Nitze-Leiter endoscopy museum, the most important endoscopic collection in the world, an ethnological collection, a collection of the history of anaesthesia and intensive medicine, the unique Josephinum library and an extensive specialist library devoted to medical history, a handwriting collection and a picture archive. Today, the Josephinum not only presents itself

as an institute and museum for the history of medicine but also as a world-renowned documentation centre for medical history.

Medical History Institute of the Medical University of Vienna

Tel.: + 43-1-4277 63401
Homepage: www.univie.ac.at/medizingeschichte/

Medical History Museum in the Josephinum

Opening hours:
Monday to Friday: 9am – 3pm
Every 1st Saturday of the month: 10am – 2pm

ⓒ Café Stadlmann

1090 Vienna, Währinger Strasse 26
Tel.: 0699/81 80 44 71
Monday to Friday 8am to 10pm

No. 19 Berggasse
A visit to the archaeologist of the soul.
Where the most famous couch in the world
does not – unfortunately – stand

Tour 14

Starting point:
Schottentor; Tram 37, 38, 40, 41 or 42 to stop Schwarz-
spanierstrasse. About a 5-minute walk downhill to
no.19 Berggasse.
Alternatively: Bus 40 A, to stop Berggasse or tram line D,
station Schlickgasse.

End:
Schottentor

Duration:
2 hours (1 hour in
the Freud museum

Tour 14

Bolzmanng.

Palais
Lichtenstein

Porzellang.

Seegasse

Strudlhofg.

Pramerg.

Serviteng.

Grünentorg.

Bauernfeldpl.

Spitalgasse

Senseng.

Porzellang.

Thurng.

Wähninger-Strasse

Bergg.

Lichtensteinstr.

Old
General
Hospital

Garnisong.

Türkenstr.

Hörlg.

Kolling.

Frankg. **Votivkirche**

U Schottenring

U Schottentor

Universitätsstr.

Landesgerichtsstr.

Schottengasse

University

Florianig.

Dr.-K.-Lueger-Ring

City Hall

U Rathaus

U Herrengasse

No. 19 Berggasse.

If you take one of the above mentioned trams from Schottentor, jump off at the first stop, and then walk down the next sloping side street, you will soon arrive at what is probably (after 10 Downing Street) one of the most famed and revered addresses in the world – 19 **Berggasse** – birthplace and grail of psychoanalysis. Alternatively, you could retrace Freud's footsteps, and take a short walk along the paths he often used himself.

Deciding on the latter, we leave Schottentor and follow the north flank of the Vienna University. In the Arkadenhof, the University's hall of fame (see tour 3) there is, incidentally, a **bust** of Freud inscribed with a verse from Sophocles' Oedipus the King: "He who solved the famed riddle and was a man most mighty". Crossing Universitätsstrasse at the first zebra crossing will bring us to the Sigmund Freud Park, an expanse of green lawn planted with young trees, where there is a memorial to the founder of psychoanalysis. It was here and in the neighbouring Votivpark, the area surrounding the imposing Votivkirche (Votive Church), that Freud liked to walk his dog after lunch and in the evenings. At this spot on May 6th 1985 a ceremony was held to unveil a memorial with a quotation from Freud. The text carved in stone and also the source of the text cited at the opening represented a classic error. Both were wrong. The inscription was wrong and the wrong source was cited. The inscription beneath the Greek letters Psi and Alpha (Freud's abbreviation for psy-

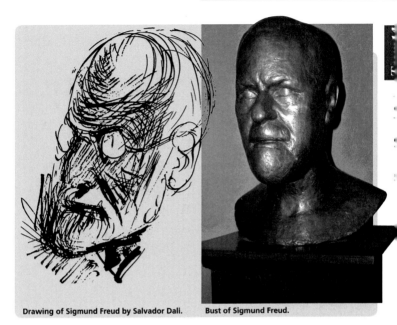

Drawing of Sigmund Freud by Salvador Dali.

Bust of Sigmund Freud.

choanalysis and still in worldwide use today) on the epitaph was "the voice of reason is a soft one..." but Freud actually wrote: "the voice of the intellect is a soft one...", and the quote is not (as was wrongly declared at the ceremony) from "Civilisation and its Discontents" but from "The Future of an Illusion" (complete works XIV/1927c, 377).Two "mistakes" on one monument ? How would Freud have reacted to such oversights? Perhaps with a knowing smile? How these changes to the citation came about, and who was responsible for them can no longer be clarified. Sometime during the 1990s the text was corrected by replacing "reason" with "intellect". For all those whose grasp of Freud-

ian literature has slipped a little, and have no intention of taking a weekend refresher course in psychoanalysis before visiting the memorial, here is a translation of the complete quotation: "The voice of the intellect is a soft one, but it does not rest until it has gained a hearing".

Leaving the Votivkirche on our left (this typical Ringstrasse building

Visting card.

PROF. Dᴿ. SIGM. FREUD

was erected as an expression of gratitude for the failure of an assassination attempt on **Emperor Franz Joseph I**), we cross the wedge-shaped Freud Park in the direction of Währingerstrasse. A circle of trees in the park – planted in 1997 to mark the occasion of the 40th anniversary of the European Union – and a granite table with ten seats for the 10 new members symbolise the dialogue within the EU and are intended to encourage visitors to rest here for a while. Upon reaching Währingerstrasse on the far side of the road, diagonally to our left, we see the exposed brick façade of nr. 10 Währinger Strasse, the Chemical Institute. This is the one of the new university's oldest buildings, and it was here that Sigmund Freud took part in chemistry exercises and (according to his own records) between March 1881 and July 1882 carried out less than suc-

Window in the staircase.

Staircase.

cessful gas analyses. He later said that he regarded the time he spent here as wasted.

Following Währinger Strasse out of town, we soon come to the junction with Berggasse. Before turning right however, we glance briefly across the road to the building on the corner of Schwarzspanierstrasse and Währinger Strasse, the Viennese Medical University's Anatomical Institute. The Physiological Institute of the eminent physiologist **Ernst von Brücke** was once housed in this former armaments factory. Freud later said of von Brücke that he was the greatest authority ever to have influenced him. Freud spent six years here, from 1876 to1882, as an assistant and demonstrator. During the next three years Freud lived and worked in various departments of the General Hospital in preparation for setting up his own medical practice.

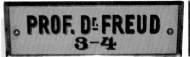

Doorplate.

After a few minutes walk through Berggasse, which is not over-endowed with beautiful buildings, we arrive at its most famous house, number 19.

A plaque placed on the façade in 1953 by the World Federation for Mental Health reminds that the "Founder and Creator of Psychoanalysis" lived and worked here from 1891 until his expulsion by the National Socialists in 1938. His consulting rooms were here, and it was also here that he wrote his case histories and books that would change the world. In 1971, Freud's one time practice and home became what is now a world-famous museum, attracting over 65,000 visitors yearly.

As was the case with Freud's patients, entry to the former consulting rooms is gained by ringing the front door bell and waiting to be admitted. Signs direct one through the **hall** with its magnificent etched **glass windows** to the museum on the first floor. The **door-plate** to the right indicates the consulting rooms, to the left the private apartment of the Freud family. Not being patients, we ring and enter Freud's private hall. Guidebooks in five languages and audio guides in German or English are provided for visitors. From the **entrance hall** we move through the museum shop and turn right into the rooms of the former medical practice. The hall of the practice, which has for the most part been preserved in its original condition, contains many pieces of memorabilia: **Freud's hat**, a **clothes hanger** from his training period in the General Hospital, his walking stick and a large travelling trunk, which he used on his forced emigration to London. Many of the exhibits that can be admired today were presented to the museum by his

Hat and clothes hangaer.

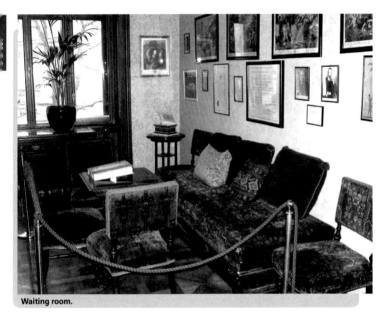

Waiting room.

daughter Anna in 1971 on the occasion of the museum opening ceremony, which she attended personally.

Passing through the hall we come to the **waiting room**, furnished with original pieces arranged according to the memories of Anna Freud and housekeeper Paula Fichtl. The room was not only used by the patients, however, the Wednesday evening Psychological Society, later the Viennese Psychoanalytical Association, also used to meet here. A display case contains part of Freud's antique collection that documents his passion for archaeology, discovering, unveiling layer for layer and finally interpreting – as he ultimately did with the psyche. Separating the waiting room from the treatment room is a sound-proof double door, and it was opposite this that psychoanalysis' most famous piece of furniture once stood: Freud's legendary couch – the divan draped with a Smyrna rug that was given to him around 1890 by Madame Benvenisti, a grateful patient. As Freud was permitted to take all his personal belongings with him to London, today the couch is in the Freud Museum at 20 Maresfield Gardens that was his home during exile. Here in Vienna the large format photo documentary by photographer **Edmund Engelmann** gives a vivid impression of the interior of the room shortly before Freud's forced emigration. The neighbouring study with Freud's library, his antiques collection and writing desk, at which he wrote his most important works, along with the unique chair de-

signed especially for his somewhat un-usual reading position – he would place one leg over the arm of the chair and hold the book up high – have been doc-umented by the photo series made in 1938. The documents, autographs and books on display in the room chronicle the life and work of Freud and the his-tory of psychoanalysis.

Today, with its exhibits of Freud's per-sonal possessions, photos, autographs, its scientific archive, the comprehensive library and a film from the 1930s with a commentary by Anna Freud, which can only be seen here and in the Lon-don museum, 19 Bergasse is not only a memorial and modern museum, but also a place for a multifaceted and en-thralling exploration of psychoanaly-sis. Frequently changing exhibitions and a contemporary art collection are intended to make visible and understandable the convergence of modern art and psychoanalysis and to document it.

We leave 19 Bergasse – those who want some time for reflec-tion can drink a coffee in Café Freud which is only a few steps away – turn to the left and at the next crossroads – the stop Schlickgasse – we take the D tram travelling in the direc-tion of Südbahnhof, which will bring us back to Schot-tentor (U2), Ring/Volktheater (U3) or on to the Opera/Karl-platz (U1/U4).

Sigmund Freud Museum

9th District, Berggasse 19
Opening times: daily 9am – 5pm
July till September: daily 9am – 6pm
Guided tours on advance notice
Tel.: +43-1-3191596
Fax: +43-1-3170279
Mail: office@freud-museum.at
Homepage: www.freud-museum.at

Library:

Open every Tuesday: 10am – 6pm

Café Berg

1090 Vienna, Berggasse 8
Tel.: 319 57 20
Daily 10am to 1am

Freud's room in

The Narrenturm – unique in both medical
and architectural terms

Tour 15

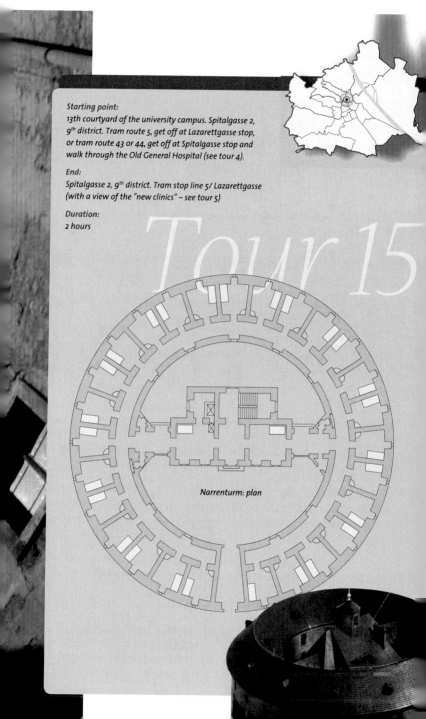

Starting point:
13th courtyard of the university campus. Spitalgasse 2, 9th district. Tram route 5, get off at Lazarettgasse stop, or tram route 43 or 44, get off at Spitalgasse stop and walk through the Old General Hospital (see tour 4).

End:
Spitalgasse 2, 9th district. Tram stop line 5/ Lazarettgasse (with a view of the "new clinics" – see tour 5)

Duration:
2 hours

Tour 15

Narrenturm: plan

Narrenturm courtyard.

The Federal Pathological Anatomical Museum, housed in the **Narrenturm** (lit. Fools Tower) is in the fortunate position of being able to present its unique and spectacular collection in a building that is equally unique and spectacular. This is an exceptional and mysterious building which no guidebook on Vienna can overlook and which is generally used as an example of Vienna's dark and slightly morbid side. At the time of its establishment however, the undoubtedly slightly gloomy, five-storied "tower with cells for the insane" was a thoroughly progressive medical institution.

Although the fortress style building, with its 139 **cells**, heavy oak doors, chains, iron rings fixed in the walls and the narrow, embrasure-like windows reminds the visitor more of a prison than of a hospital, this building documents the beginning of "care of the insane" in Europe. Although this kind of "nursing" may appear offensive and inhuman to us today, at the time it was built the Narrenturm represented an enormous advance in the care of mentally ill and dramatically improved their lot in Vienna. Up till then – not only in Vienna – "lunatics" were treated like criminals, locked up in old prisons and "left to rot in their own filth".

The Narrenturm was the only facility to be entirely newly erected in the course of establishing the Allgemeines Krankenhaus (General Hospital, now the Old General Hospital) in the year 1782.

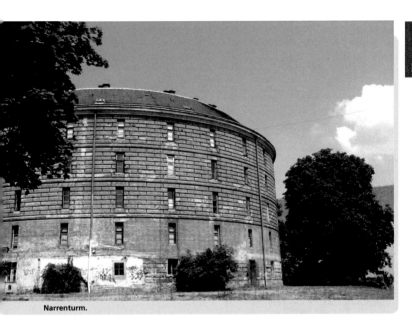

Narrenturm.

Joseph II "only" had the existing Gross-armenhaus (poorhouse) structurally adapted to create the enormous complex of what was then the new General Hospital. It seems certain that the emperor had a great influence on the planning and design of the new building. Joseph II's particular fondness for this building has become legendary. There have been intensive discussions about the actual motive for the emperor's rather surprising interest in the tower. The shortlist of possible explanations includes: the tower as an alchemistical "magnum opus", as a facility for astronomy, metaphysical astrology, mystical numerology or perhaps simply on account of the view from its roof over

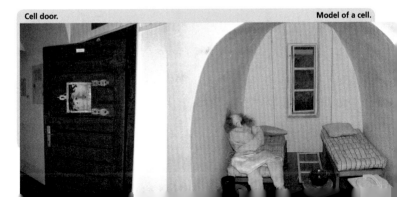

Cell door.

Model of a cell.

the hospital that he had created for the "healing and consolation of its patients", of which he was (quite rightly) probably very proud.

Whatever the emperor's motives: the Narrenturm was the first specialised institute in Europe devoted exclusively to the mentally ill, and represents the beginning of humanitarian psychiatric care in Vienna. Under a new moon, early in the morning of April 19, 1784, the first "lunatics" were brought from a number of Viennese hospitals to their cells in the newly built asylum. In a letter he wrote personally some days before, in which he displayed considerable detailed knowledge, **Emperor Joseph II** gave orders how the tower was to be used, and which patients were to occupy it. The tower was generally considered a sign of the emperor's philanthropic interest in "lunatics" – which indeed it was. When one looks at the dungeon-like cells, in which the most troublesome and "unclean" patients were chained up and had to eke out their existence on beds of straw, one can well imagine the even more gruesome treatment that lunatics received in institutions outside the Narrenturm. Although in the tower lunatics suffering from fits were chained up for their own protection, the staff were expressly and strictly forbidden to mistreat the patients in any way.

General Hospital and Narrenturm 1784.

Narrenturm – historical photograph.

Record books.

Alchemist's laboratory.

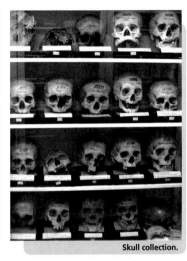

Skull collection.

Quite soon the Narrenturm became a highly popular attraction and amusement in Vienna. For a small tip, the warder would allow the esteemed public to inspect the tower, and – which was much more amusing – the crazy inmates. A contemporary travel report from London shows that back then this was not a uniquely Viennese pastime: "my three little boys and I inspected the lions, the bridges, the lunatics of Bedlam and other amusing attractions of the metropolis". In Bicetre, the notorious Parisian lunatic asylum, the patients were exhibited as "wild animals to the first rowdy who pays 6 ha'pence to see them". The first to forbid access to inquisitive sightseers was **Johann Peter Frank** (1745 – 1821) director of the General Hospital, who in 1796 established a garden reserved exclusively for the patients. In 1784, the two most junior head doctors in the internal medi-

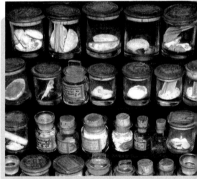

Urinary stone collection.

cine department were assigned the job (most unpopular among doctors at the General Hospital) of treating and looking after the patients in the Narrenturm. It was only in 1817 that the Narrenturm received its own head doctor. However, the chains in the tower remained in place until 1839, when they were finally removed by order of head doctor

Michael Viszanik (1792 - 1872). The Narrenturm housed patients until 1866. Thereafter the "lunatic container" served as a workshop, staff accommo-dation and offices for the doctors and nurses of the General Hospital.

Since 1971, this most extraordinary ex-ample of Josephinian architecture has housed the world's oldest and larg-est collection of pathological anatom-ical specimens, with approximately 50,000 exhibits. The basis for the sys-tematic collection of pathological ana-tomical specimens was a directive of the health authority from the year 1795: "Since a hospital to which 14,000 patients of every kind are admitted annually presents a great opportunity to collect pathological anatomical speci-mens, it is ordered that all doctors of the General Hospital should collect unusual specimens and preserve them in alcohol. The hospital will provide the

Skull with holes

required alcohol on instruction of the doctor in charge." It was only under the world-famous pathologist **Carl von Rokitansky** that the collection attained scientific value, despite the fact that the museum was in dire need of space at the time. In 1862, after the opening of a new building for the pathological anatomical institute, the precious collection could finally be presented in bright and airy rooms.

In the second half of the 20th century, the collection, which was moved in 1971 to the Narrenturm, developed into a kind of "European Central Medical Museum" where many international collections, which were discarded due to lack of space or interest, finally found a home. The collection grew from 7000 to about 50,000 objects and today is still continuously expanding.

The museum is divided into two sections. On the ground floor the exhibited collection informs the medical layman about aspects of medical history, the clinical pattern of various illnesses, the pathologist's profession and the history of the tower itself. Presentation panels, statistics, historical and current newspaper cuttings explain, among other things, the history and treatment of classic infectious illnesses such as syphilis and tuberculosis. In addition to a completely equipped pharmacy dating from the 1820, a historical birthing chair and a dental practice from the 1960s, the development of artificial limbs is also documented. A particularly fine exhibit is the travelling case of a representative of an English orthopaedic company

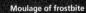

Moulage of frostbite

Moulage of Lepra tuberasa

Aleppo boils

containing doll-size samples of artificial limbs. In the room dedicated to gastro-intestinal diseases visitors can discover a curious item: alongside depictions of everyday illnesses, such as gastric ulcers and intestinal polyps, is a ball of horse hair and string found in the stomach of a psychiatric patient who once ate his mattress. Dissecting tables and instruments provide an insight into the pathologist's work.

The scientific collections in the upper storeys can only be inspected if you take the guided tour (highly recommended). You can find there endless rows of skeletons deformed and altered by disease, glass jars containing miscarriages without brain, heart and limbs, Janus-faced specimens, Siamese twins, sirens, cyclops, malformed faces and bodies and also artistically impressive **moulages** – painted wax and paraffin models of diseased body parts which, before the invention of colour photography, were the only available method of clear documentation and that illustrate illnesses even whose names are probably unknown to modern medical practitioners. One can also find here curiosities like the moulage of the damage sustained by a professional showman who let himself be repeatedly X-rayed in a darkened tent at the beginning of the 20th century to exhibit his bones and beating heart to an audience. A rarity is Vienna's only remaining stuffed model, prepared by removing the skin from a corpse and then stuffing it. The most famous stuffed models were once in the k.k. Hofnaturalienkabinett (Royal

and Imperial Collection of Natural Specimens), but were destroyed in a fire during the 1848 revolution.

What is probably the world's most extensive medical historical collection, also includes old and new medical equipment, coins and stamps with medical motifs, the third largest microscope collection in the world and an extensive collection of professional insignia of medical care professions from different countries.
Today only a small proportion of the valuable collection is used as learning material for students of medicine and other medical professions. Far more important is the documentation of diseases and their history over more than two centuries. Diseases that today either no longer exist, or that, thanks to new forms of therapy – for example antibiotics – fortunately no longer occur in this form or to this extent.

Federal Pathological-Anatomical Museum in the Narrtenturm

Altes Allgemeines Krankenhaus
(Old General Hospital)
University Campus, Hof (courtyard) 13
9th District, Spitalgasse 2

(You can also enter the complex from Van-Swietengasse or Sensengasse)

Opening hours:
Wednesday: 3pm to 6pm
Thursday: 8am to 11am
Every first Saturday of the month
10am to 1pm
Closed on public holidays

Tel: +43-1-4068672
Fax: +43-1-40686755

Homepage: www.narrenturm.info
(lecture times and events)

Universitätsbräuhaus

1090 Vienna, Alser Strasse 4, (Campus, Old General Hospital, 1st Hof)
Tel.: 409 18 15
Daily 9am to 2am

Stiegl Ambulanz

1090 Vienna, Alser Strasse 4, (Campus, Old General Hospital, 1st Hof)
Tel.: 402 11 50-0
Daily 11am bis 12 midnight

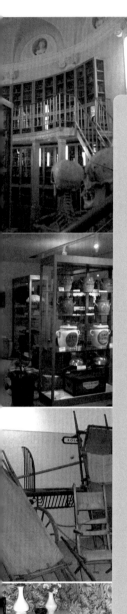

Museum
Tour

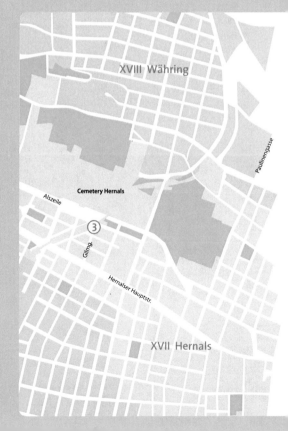

XVIII Währing

Paulinengasse

Alszeile

Cemetery Hernals

③

Gilmg.

Hernalser Hauptstr.

XVII Hernals

1. Museum of the Department of Forensic Medicine
2. Museum of the Institute of Pharmacognosy
3. Museum of the Viennese Emergency Medical Services
4. Museum of Dentistry, Oral and Maxillo-Facial Medicine

Museum Tour

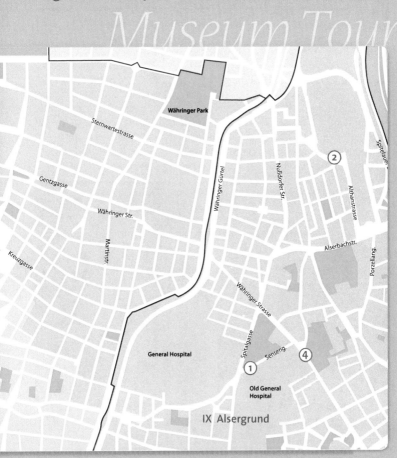

The detective with the scalpel

The Museum of the Department of Forensic Medicine, Vienna Medical University

The Museum of the Department of Forensic Medicine is not only one of the most extensive and interesting collections of forensic medicine in the world, but also offers a fascinating insight into the many different facets of the work performed by the "detective with the scalpel". With over 2000 exhibits this is a unique "living" textbook of forensic medicine.

The history of the collection first started in 1875, although the chair of forensic medicine had been in existence since 1804, making it the oldest in German-speaking Europe. In 1815 a separate "chamber for the opening of corpses" with (for its time) very modern facilities

was opened at the corner of Spitalgasse and Sensengasse. But it was not a forensic physician but a pathologist that was appointed forensic anatomist. The master of pathological anatomy, **Carl Rokitansky**, had been a forensic anatomist since 1832. Rokitansky made use of this fact and moved all forensic and public health autopsies to his institute. Forensic medicine, which under Rokitansky had become just an area of pathology and was devoted little attention, developed under his successor **Eduard von Hofmann** (1837 – 1897) into a new modern science.

The actual founding of the Museum of Forensic Medicine falls within this period. Hofmann collected considerable amounts of illustrative material so that he could make his lectures – which were attended not only by medical but also by law students – more interesting. Hof-

Eduard von Hofmann.

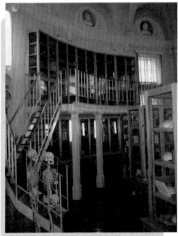
Museum of Forensic Medicine.

mann achieved fame through the autopsies he conducted on the corpses of the 200 victims of the Ringstrassentheater fire. The collection contains the charred head of a copse from this horrendous fire on which the autopsy was carried out on 10.1.1882, as well as his report on the death of Crown Prince Rudolf in Mayerling. Forensic medicine in Vienna reached a high point under Hofmann and his classic "Lehrbuch der gerichtlichen Medizin" (Textbook of Forensic Medicine) spread the fame of Viennese forensic medicine throughout the world.

Leopold Breitenecker, who took over the chair in 1959, reorganised the valuable contents of the collection and catalogued them. In its present form the museum is largely the result of Breitenecker's personal commitment. The museum is laid out according to the chapters of forensic medicine and each cabinet is devoted to a particular theme. In addition to specimens the museum also possesses an extensive collection of weapons used in crimes and murders. Every category is represented, from primitive tools to the most modern weapons. The sharpened file with which **Luigi Lucheni** stabbed Empress Elisabeth to death in Geneva on 10 November 1898 was also once in this museum. Today this weapon is displayed in the Sisi Museum in Vienna (see Tour 2). The head of the assassin Lucheni is also in Vienna. On 24 December 1985 the head of the murderer, preserved in formaldehyde, was sent from the forensic medicine institute in Geneva to the Pathological-Anatomical Federal Museum in the Narrenturm. However, visitors were never permitted to view the head. In 2000 the specimen that by then was in a poor condition, was finally buried in what are known as the "anatomy graves" in Vienna's Zentralfriedhof.

The specimens in the museum offer a unique overview of the various causes of death, both natural and artificially induced, as well as showing the changes caused to corpses by fire, water and electrical current. A display cabinet that is reminiscent of a butterfly or moth collection is inscribed with the title "Leichenflora". It is possible to deduce the approximate date of death (among other things) from the stage of development of fly larvae and other animals found on corpses that have been left lying for a considerable period. There are also specimens that document a number of the major criminal cases from the previous century. A collection of autopsy reports that extend back as far as 1842 completes this extraordinary "textbook" of forensic medicine.

Museum des Departments für Gerichtliche Medizin / Museum of the Department of Forensic Medicine

9th District
Sensengasse 2

Contact for enquiries and tours
Tel.: +43-1-4277 65701

At present the museum is not open to the general public. Visits can only be made by those with specialist training in this field, following prior appointment.

Dragon's blood and castoreum

The historic collections of the Institute for Pharmacognosy

The Museum of the Institute for Pharmacognosy provides information not only about rare plant, mineral or animal-based drugs from practically all parts of the world but also exhibits historically important and pharmaceutically valuable apparatus from laboratories, pharmacists' appliances, containers, and pharmacopoeia from several centuries. Pharmacists' inventories, mortars, distillation appliances, strange packages, containers made of wood, pewter, glass and porcelain offer the visitor information about the exciting history of pharmacy.

The Institute contains two historic collections: an extensive drug collection with about 18,000 rare plant and animal-based drugs, and a collection of the history of pharmacy with pharmaceutical appliances and pharmacopoeia dating back as far as the 17th century. The drug collection was built up under **Damian Schroff**, who collected drugs and herbariums as illustrative material for his lectures about "pharmacognosy for physicians and pharmacists". Schroff endeavoured to continuously enlarge the collection through acquisitions and his own activity as a collector. An interesting part of the collection, drugs and medicines mostly from China and Chile, comes from material collected during the scientific expedition of the imperial frigate Novara, which sailed around the globe from 1857 to 1859 and brought back rich booty from the field of the natural sciences. The medicines, which were a sensation at the time, and, due to their unique quality, were immensely valuable are still kept in their original containers.

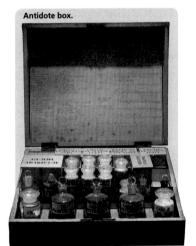

Antidote box.

Destillation appliance.

The originally rather small collection relating to the history of pharmacy was expanded considerably when in 1977 various appliances from the imperial and royal court apothecary were taken over by the Institute. After the closure of this apothecary in 1991 – today its rooms are occupied by the Lipizzaner Museum – its entire inventory was incorporated in the Institute's collection. Other interesting pieces came from the former Bundesanstalt für Chemisch-Pharmazeutische Untersuchungen (Federal Institute for Chemical and Pharmaceutical Examinations), the apothecary of the old General Hospital in Vienna, and as donations from private individuals.

The most interesting exhibits in the two collections can be viewed today in an attractive setting. Rare animal-based drugs such as crab eyes, which are lime concretions from the stomach of the crayfish, dried scorpions, sea horses and corals are to be found here alongside a head of an Egyptian mummy that, under the name "mumia", was used to produce plasters and a remedy for wounds until the end of the 18th century in human medicine and even until the end of the 19th century in veterinary medicine. Strange packaging used to transport material is also exhibited such as aloe in ape skin, cibet packed in horns sealed with animal skin, bamboo cane used to transport Chinese mercury and magnificent tea crates dating from the 19th century and covered with coloured paper. Today such items of packaging material from which one could recognise the quality and origins of the goods are rare pieces, but as they were

once regarded as worthless they were often damaged and only few survive today. Castoreum, the contents of the secretion organ of the beaver which was used by the Greeks and Romans to treat various complaints, is exhibited here, as is Asian dragon's blood – originally the resin of the dragon's blood palm, later different kinds of red coloured resins used to coagulate the blood and for treating intestinal diseases.

Among the most exquisite rarities are a little wooden **antidote box** with the original contents from 1865, and a metal medicine chest of the Knights of Malta, which was used in railway ambulance cars from 1878 onwards. Ancient pharmacy books, pill machines, suppository forms, mortars, presses, microscopes and magnificent distillation appliances complete this unique collection that, as far back as 1898, was regarded as an important scientific and tourist sight in Vienna.

Museum des Instituts für Pharmakognosie / Museum of the Institute of Pharmacognosy

Pharmaziezentrum
Entrance from Josef Holaubeck Platz
(beside the Wirtschaftuniversität, opposite the Verkehrsamt)
Postal address: Althanstrasse 14, 1090 Vienna

Visits and guided tours are possible only with a prior appointment.
Enquiries should be made to:
Prof. Dr. Christa Kletter
Tel.: +43-1-4277 55244
Fax.: +43-1-4277 9552
e-mail: christa.kletter@univie.ac.at

We're on our way!

The Museum of the Viennese Emergency Medical Services

Until the second half of the 19th century first-aid services and the transport of injured or acutely ill persons were poorly developed and there was no organised form of transport of the sick. Lanternmen, corpse-bearers or caretakers were used from time to time to transport sick people. Portable beds and stretchers on wheels were kept in the council offices in the individual districts and in the police stations. It was not unusual for a patient to suffer further damage to his health as a result of unprofessional transport.

The idea of **Jaromir Mundy** (1822 – 1894) to set up a voluntary first aid and rescue service was initially rejected by the authorities. It was only the appalling **blaze in the Ringtheater** on 8.12.188, in which 386 people attending a performance of Jaques Offenbach's *Tales of Hoffmann* were asphyxiated by smoke, burned or trampled to death, that showed the authorities and also the populace at large that the existing emergency services were helpless in the face of such a catastrophe. On the very next day Mundy got to work. Together with his friends **Hans Wilczek** (1837 – 1922) and **Eduard Lamezan** (1835 – 1903) on 9 December 1881 he founded the "Wiener Freiwillige Rettungsgesellschaft" (Viennese Voluntary Rescue Society).

Mundy secured the finances needed to continue the rescue society through donations, collections and charity events. On 24 May 1885 **Alexander Girardi** performed in the Rotunda at one such event in aid of the society, passing by in a *fiaker* (a kind of horse-drawn cab and the person who drives such a cab) and singing for the first time ever the **Fia-**

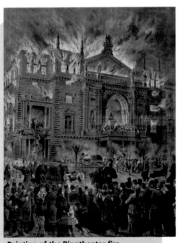

Painting of the Ringtheater fire.

Fiakerlied, 1885.

Uniform caps.

Minute books.

kerlied (fiaker song). **Johann Strauss the Younger** composed the march *Freiwillige vor!* (Volunteers Ahead!) especially for the society and dedicated it to the first charity ball held by Wiener Freiwillige Rettungsgesellschaft on 30 January 1887. In addition to support from businessmen and members of the aristocracy the society also received help (not only of a financial nature) from **Theodor Billroth**, a longstanding friend of Mundy's.

Mundy, who had suffered for a long time from serious depression, shot himself on 23 August 1894 beneath the Sophienbrücke (today the Rotundenbrücke) on the banks of the Danube Canal. But the model of the rescue and emergency society that had in the meantime been copied throughout the world survived the death of its founder. Gilmgasse emergency station was created in 1904 through the conversion of an emergency hospital that was no

"Freiwillige vor!", 1887.

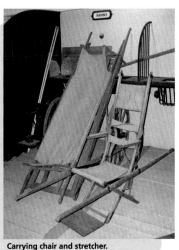

Carrying chair and stretcher.

longer needed. In an extension stables, sheds and accommodation for ambulance men and coachmen, and, at the centre of the courtyard, a disinfection centre were made. In addition to the emergency station the building today contains the historic collection of the Viennese emergency and rescue services. The objects displayed range from **stretchers** and a **carrying chair** constructed by Mundy himself to **uniform caps** and sleeve insignia to emergency cases, doctor's bags, medical dressings and remedies. Minute books from 1883 to the present day and a collection of tools and objects that caused injuries or prevented them are also shown here, as is the **death mask** of Jaromir Mundy with the bullet hole in the right temple.

Instructional panel on re-animation.

Museum der Wiener Rettung / Museum of the Viennese Emergency Medical Services

Sanitätsstation 17 Hernals
17th District
Gilmgasse 18

Please phone in advance to arrange visits or tours
Tel.: +43-1-71119 70070 – Mr. Erhart
Fax: +43-1-71119 70079
Email: post@ret.magwien.gv.at

Mundy's deathmask with the bullet hole.

From the tooth-extractor to the dentist

*Museum der Zahn- Mund-
und Kieferheilkunde
Museum of Dentistry, Oral and
Maxillo-Facial Medicine*

Dental equipment.

A single look at the historic dental instruments in the Museum gives even the most hardened visitor moist palms, making him or her mutter a silent prayer of gratitude for the blessings of modern medical technology. The historical development of the instruments used by dentists dramatically presents the medical layman with the benefits of the technical advances made in this area of medicine. The Museum of Dentistry, Oral and Maxillofacial Medicine is today only a few steps away from the building where the basis was laid for scientific dentistry in Vienna. In the Josephinum, the former military medical academy, **Georg Carabelli von Lunkaszprie**

Georg Carabelli von Lundkaszprie.

(1787–1842) was the first doctor to give lectures on dental medicine from 1821 onwards.

But university-trained dentists remained rare for a long time. Most of those people who treated dental problems practiced dentistry as a licensed trade without any medical training or knowledge. In the daily newspapers they praised their elixirs, powders and miracle cures and extracted teeth with **instruments** that today make one queasy just looking at them.

Accordingly, at the beginning of the 19th century dentists had a poor reputation. An anecdote about **Moriz Heider** (1816–1866), Carabelli's successor, illustrates how bad this reputation actually was. Carabelli wanted to persuade his most gifted pupil to become his assistant. Heider is said to have responded to Carabelli's request as follows: "An honest man who has learnt something can't become a dentist."

But Heider ultimately did become a dentist. After his death Carabelli left Heider his valuable collection of dental specimens, all his instruments and his practice. It was then up to Heider

183

Moulages of war wounds from the 1ˢᵗ World War.

to continue Carabelli's work. In addition to his political activities Heider carried out pioneering work in the area of dental technology. And it was also he who introduced a new technique into dental medicine that was then taken over by surgery as a whole: galvano-caustic treatment. During a conversation with the Munich physicist Steinheil Heider came upon the idea of replacing the branding iron that was used to de-

stroy the tooth nerve by an incandescent electrical apparatus, a glowing hot platinum wire. In his book published in 1846 he remarked that this method could probably also be used in surgery. Heider can therefore be seen as the inventor of galvano-caustic treatment.

The Museum of Dentistry, Oral and Maxillo-facial Medicine is today housed in an annexe of the Dental University Institute. A part of this collection, which is probably the largest in Europe, is over 150 years old and dates back to Carabelli's collection. Portraits, graphic works, documents and instruments and machines, some of them terrifying to behold, convey an overview of the development of scientific dental medicine in Austria. Simple narcotising appliances for the inhalation of ether or laughing gas show the efforts of dentists to make their activity, a source of fear for almost every human being, as painless as possible.

Dentist's chair, around 1930.

The **moulages** of mouth and jaw injuries from the First World War show in a realistic way the horrors of war. These wax models of war injuries (that had never previously occurred on such a scale) are true down to the last detail and served as teaching and demonstration material for the training of dentists and maxillo-facial surgeons. One of the most important pieces in the collection is a **dentist's practice** from 1870 with the original fittings. Even the stencilled painting on the walls dates from this time. All that is missing is the hand-towel over the rail on which the dentist wiped his bloody hands. Water, not to mention running water, was not a standard feature in dental practices at this time.

A collection of appliances and apparatus from the areas of dental and x-ray technology rounds off this extensive documentation of the development of dental medicine from the vagabond tooth-extractors and quacks who offered their services at the market, to a recognised branch of medical science.

*Museum der Zahn-, Mund-
und Kieferheilkunde /
Museum of Dentistry, Oral
and Maxillo-Facial Medicine*

9th District, Währingerstrasse 25a
Intending visitors should telephone in
advance with Dr. Kirchner (maxillo-facial
orthopaedics)
Tel.: +43-1-427767111

Register of Persons

Printed in the United States
By Bookmasters